Mister Sam Shearon's

Creepy Christmas

ISBN: 978-1-944109-22-6

VESUVIAN BOOKS

Published by Vesuvian Books
www.vesuvianbooks.com

Printed in the United States of America

10 9 8 7 6 5 4 3 2 1

The Winter Warning

Winter comes but once a year
Though not a time to live in fear
A warning must be given here
Be understood and made clear

To those who don't spread joy and love, who misbehave and push and shove
Who scream and kick with want and greed, who don't believe, who scoff will seed...
An evil growth that's from within, older and darker than guilt or sin

It is said there are creatures who listen always
Who whisper in the wind and cause shadows in the hallways
They watch from the closet, they're under your bed
Some peeking through the window, from the gutters above your head
They hide in the attic, they dwell in the cellar,
They've always been here and will be forever

So leave some gifts, perhaps a treat, for the ones who wait in the snow and sleet
Make a wish or say your prayers, for a peaceful season without scares
Now spread good will, share joy and cheer
For the yuletide spell is almost here

If you've been naughty all year long, if you've caused pain and done some wrongs
Your comeuppance won't be long
For the one called Krampus, with his tongue, will taste the air from your frosty lungs …

He'll snatch you up from your very bed, you'll be missing, presumed dead
From your fate you cannot run, until you right the wrongs you've done

To the wolves you might be thrown, if love and warmth of heart not shown
Snow demons will whip and they will beat, they'll torment you, treat you like meat
The lonely snowmen will stare without blinking, if you're seen to be mean or cruel without thinking
With their branches, they'll point you out, if you throw a tantrum or if you pout

Be honest, be true and stick to the course, or you might have a visit from an undead horse
Perhaps a goat with bells on its horns, perhaps an owl whose gaze will scorn

So take heed and do not stray, as you might chingle all the way
Shaking in fear you'll wreck the halls, in silent fright you'll try to call
They'll wish you a scary Christmas and a happy new fear
The trolls will bellow and the harpies will cheer …

This warning mustn't be taken lightly, as prayers and wishes are cast out nightly
For what you want, you hope and pray, to get your gifts on Christmas day
But it's not about what you might get
Focus on giving, is your best bet!

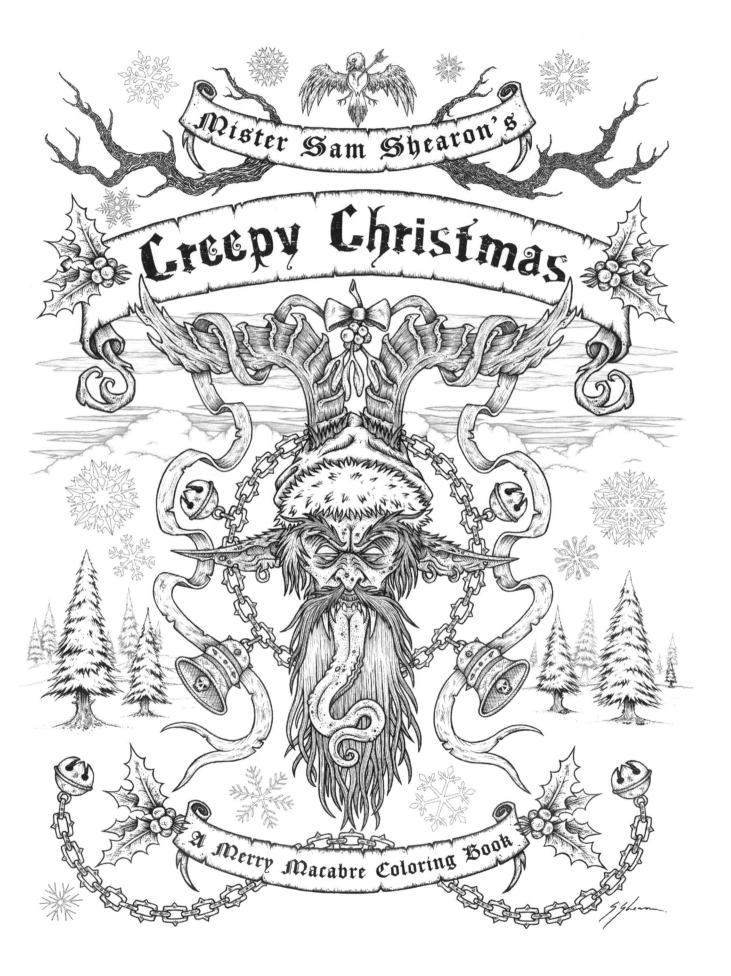

Those Who Prey

Superior to humans in intelligence and power
Those known as harpies, on souls they devour
Angels to some, though Demons to others
To Cherubs and Seraphim, they're Sisters and Brothers

Some bestow wishes and evoke only love
Though some aren't so friendly and hunt from above
A few practice peace, yet others bring Hell
Like the right hand of God, from Heaven they fell

With tattered wings and talons they prey
On the unsuspecting wanderers of wonder they slay
To doubt there is goodness and light in the world
Into the abyss, these lost souls are hurled

Atop the Yule tree, a star might be placed
Or sometimes a ribbon, or bow made of lace
Some place a "Fairy" or "Angel" it's called
Though if you saw one for real, you'd certainly get mauled

They sit in the trees, way up high looking down
Ready to strike, swooping down to the ground
Like a raptor, their claws sink deep into flesh
They then fly you away, to eat in their nest

Some say they were human, at some point in time
They're found throughout legend and nursery rhymes
One thing is sure, if you pray to the gods
You're in with a chance, at beating the odds

If you do not pray, then you have been marked
To be faced with an Angel, of light or of dark
To be judged for your sins, they will take you away
These "snatchers", these Harpies, are those who will prey!

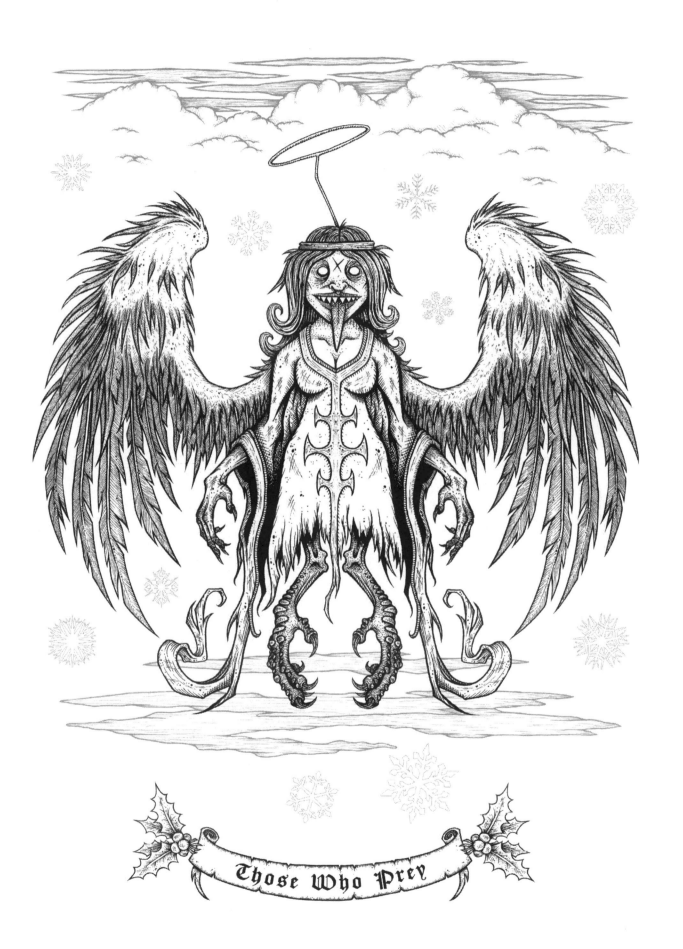

Those Who Prey

Wassailers

From today all the way back to ancient times
The distance between the wealthy and the poor's just as wide …

In ancient Greece and Babylon
Or further back, it is unknown
There is an act of trade, in a way
In exchange for song and good will, some would pay
In the form of gifts, or drink or food
The neighboring folk, would lighten the mood
From door to door, they'd spread good cheer
Leaving households, grinning ear to ear

But prior to this, in darker ages
Things were not fair
As low were most wages
As the cold set in and many families despaired
This was something for which, the rich didn't care …

So bands of rowdy young men would invade
In the homes of the rich, demands would be made
So as not to be cursed, food and drink would be paid
Like Halloween tricks, unless treated, were played
By those who into, lavish homes they did raid
Didn't always give thanks, but instead misbehaved!

These "Wassailers" are known as "Carol Singers" today
Spreading joy and well-being without fear, so they say
No longer are tricks played upon neighboring folks
Only pleasant singing and cheer … okay, sometimes jokes

Accompanied by the Yule Goat, or someone in his guise
Be wary of such things though, don't meet your demise
As the singers outside in the cold at your door
May not be what they seem, so read up on folklore …

The great goat of winter and his helpers that feast
These creatures don't worship the star in the East
Possessed by the ancient spirits that linger
These horrors at your door, may not be carol singers!

Don't offer them wine, or food in a bowl
All they truly will want, is to swallow your soul!

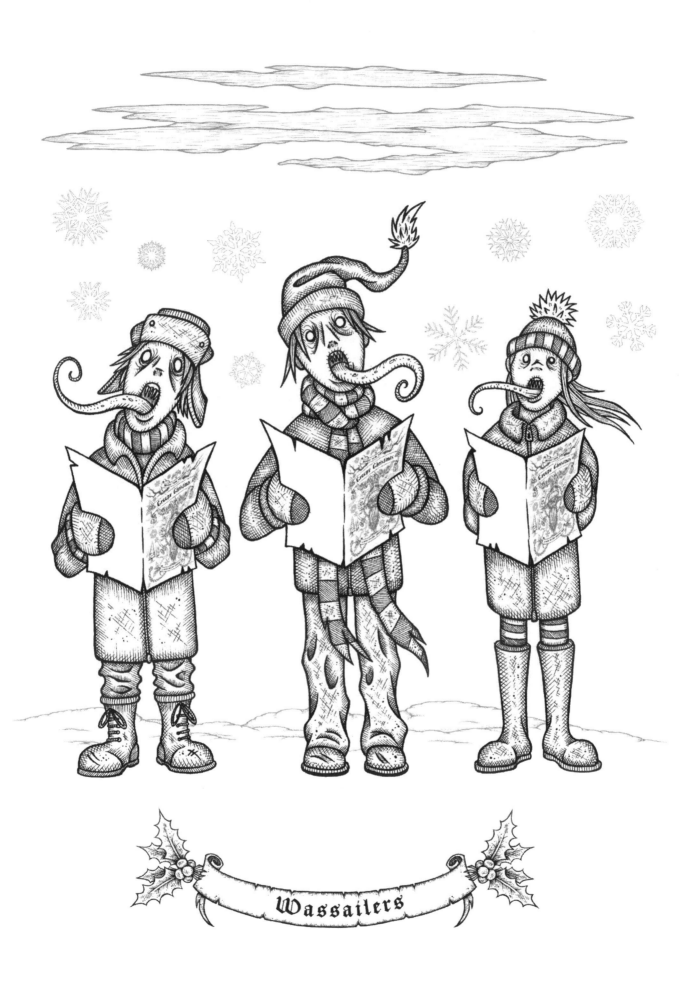

Wassailers

The Yule Goat

Scandinavian tradition in the winter gives note
To the one who brings song, in the form of a goat
He'll knock on your door with his horns wrapped in ribbons
Of the brightest blood red, to him wine is thus given

Julbocken they call him, a man-sized goat figure
He'll accompany carol singers and play pranks as they snigger
He can be quite scary and demand gifts at your door
Of him there are effigies, made out of straw

He's told to embody the spirit of the harvest
The last sheaf of corn, is often saved for powers harnessed
To ensure the Yule preparations are done right
He'll visit invisibly to check on you at night

With bells on his horns and bound in red cloth
Huge statues are made of straw held aloft
Like Trojan horses they're placed in town centres
Bad luck will be cursed if burned down, thus protected

In Finland they call this great beast "Joulupukki"
Some say to destroy these great goats is unlucky
In Sweden they build the great "Gävlebocken"
It is certainly something that can't be forgotten!

Depicted as a goat that is sometimes half man
resembling as such, not unlike the god Pan
A satyr perhaps, companion to the nymphs
Somewhat also like Baphomet, but lacking the wings

Some depict him led, by Saint Nicholas to revel
As a symbol of power, over the Devil
Though some say his origins pre-date Christian lore
There are legends throughout Pagan history galore
There is one thing, we can be certain for sure
The Yule Goat's firmly hoofed, deep in folklore!

𝕶𝖗𝖆𝖒𝖕𝖚𝖘

In Austro-Bavarian Alpine tales
From ancient legend and folklore there hails
A half-goat, half-demon said to hand out
No presents, but punishment, to those naughty with clout!

He's the shadow of Saint Nicholas, a great horned beast
His origins are pre-Christian and of Pagan beliefs
Children are warned to behave and to be good
Lest Krampus will take them away to the woods!

"Gruss Vom Krampus!" … to some he's the Devil
This cloven hoofed horror, is on another level
His role is to remove, those nasty and cruel
Those badly behaved, the unruly, those fools!

He's a force of super-nature, a monster of myth
Though if you doubt his existence, call his name to the mists
He'll answer your call, he won't hesitate to harken
Then a storm will roll in and the sky it will darken …

Krampus, it is said, has his loyal helpers
Though just like the Elves, they're nasty little yelpers
They'll snitch on you and drag you to his realm
In the dark you'll find Krampus, sitting at the helm

He's huge and he's hairy, his fingers are clawed
With an old gnarly face and goat horns he's adorned
A bundle of birch branches is brandished it's sung
And between his great fangs, out lolls his long tongue

He thrashes his chains for dramatic effect, to strike fear in the naughty, no mercy they'll get
Bells hang from his belt of various sizes, he considers the badly behaved as his prizes
He'll bundle them away in a basket on his back,
Transported to hell, they're given no slack
He'll drown or devour them on "Krampusnacht"
Past December the 5th there's no turning back!

In the Krampuslauf parades, his guise is worn then
He appears on greeting cards, called the "Krampuskarten"

His legend is told to keep children behaved
And those who don't listen are either stupid or brave
Perhaps not so fearless they'd be at his sight
They'll beg for forgiveness on Krampus night!

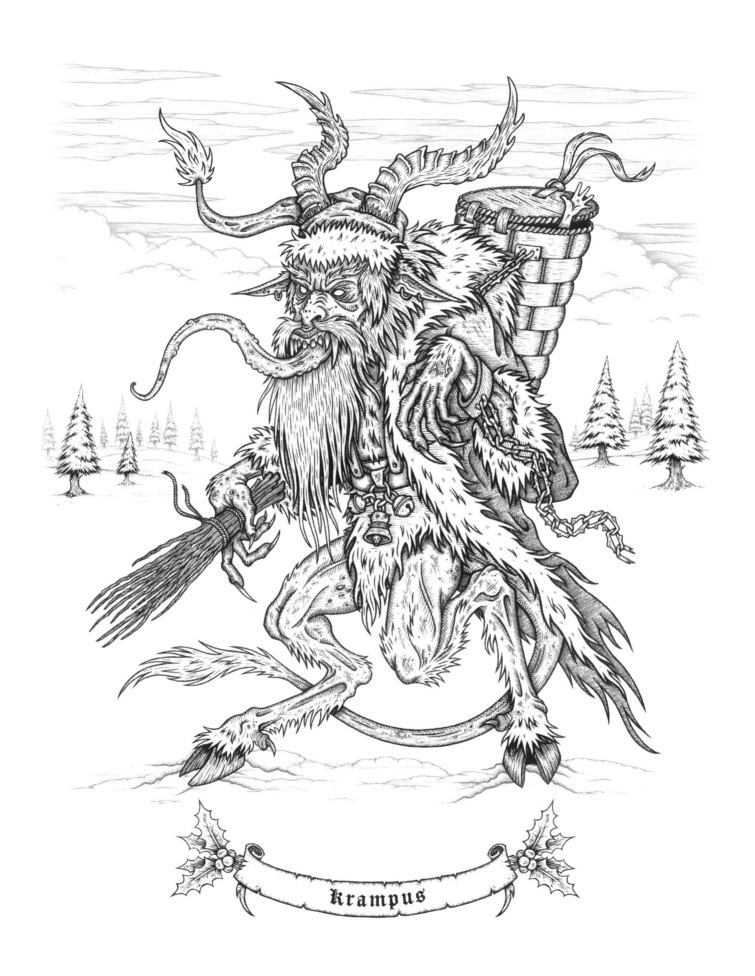

krampus

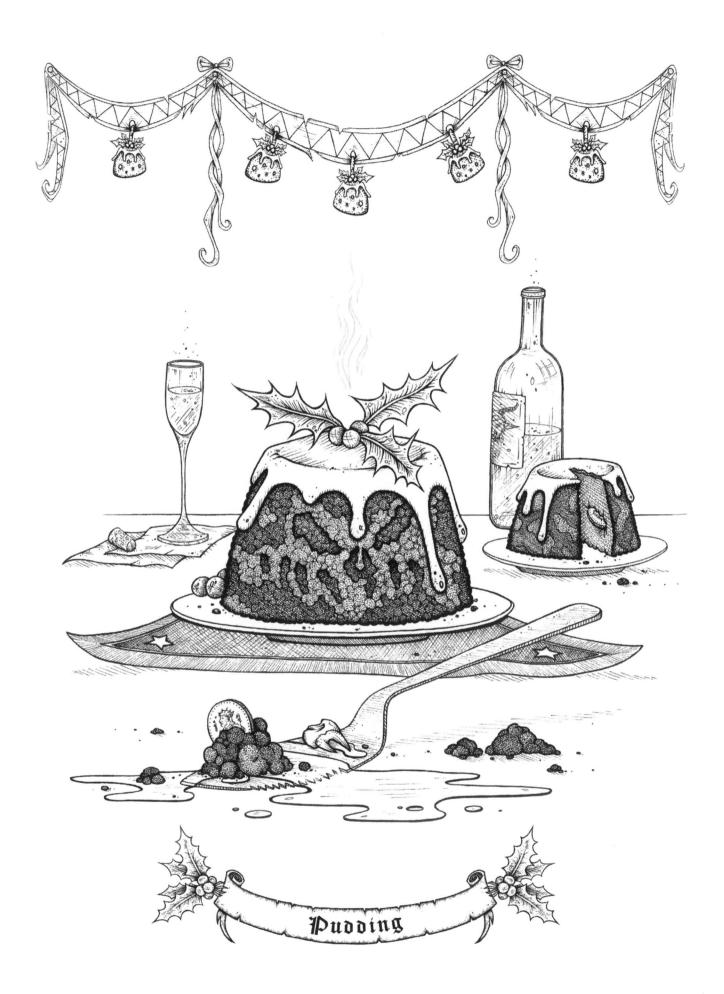

Pudding

Robin Deadbreast

The old world flycatcher, "Erithacus Rubecula"
The gardener's little friend indeed and quite the little regular
Unafraid of man, unafraid of beast
They hop on in, when the grounds disturbed, in search of insect feasts

The males who wear, the proud red breast
Like an emblem of war upon their chest
Are territorial and often quite aggressive
They kill their own kind and are very possessive
They'll attack other birds often ending in death
Who knew such a sweet thing could act like Macbeth?

They'll sing all day, a little past sunset
Before the sun rises, they're all ready, you bet!
They whistle their way, through the whole sodding day
It can become quite annoying, in a torturous way

This storm cloud bird, sacred to Thor
Appears throughout Europe in various folklore
Then there's "Who Killed Cock Robin?" (yes that old rhyme)
Which was never truly in question, by the second line

They're considered to be Britain's national bird
A title I'm sure, that most haven't heard
The postmen of Britain, the servants of the crown
Once wore a red uniform, while delivering around
In Queen Victoria's reign, when we started using stamps
In the age were we still lit the night, with gas lamps
The 'Red Breasted Robin' became the postman's nickname
The national moniker, with fondness became fame

However not all is so romantic or pleasant
If a robin flies into your house, death is present
If they peck at your window, the same applies
It's seen as an omen, that someone soon dies

If you're foolish enough to kill one for some reason
Perhaps it's annoyed you, by singing all season
The hand that you used will forever shake
For it was not for you, its life to take
Now quickly, be sure, to make a wish on the sight
Of the first robin that season, before it takes flight
For if you do not, your whole year will suck
For the curse of this folklore, is twelve months bad luck!

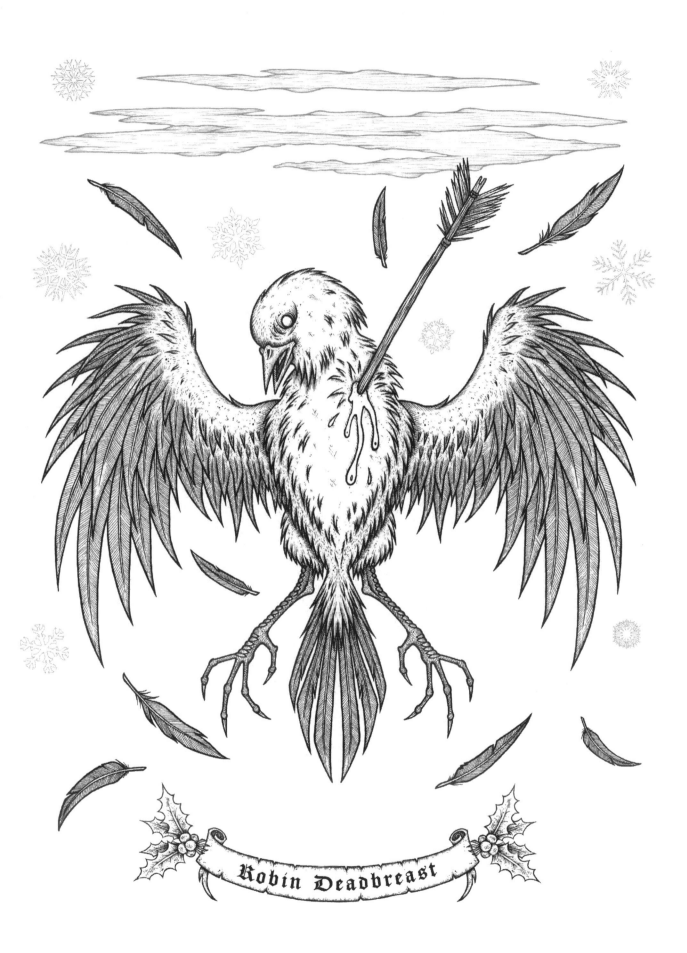

Robin Deadbreast

Snow Globe

Some call them a "Snow Dome" or simply "Snowstorm"
Depicting a snow scene in miniature form
When shaken of course, one thing is for sure
The Snow Globe is something, many people adore

Traditionally made of blown glass
Filled with water inside
When shaken creates a blizzard as such, fake snow on an internal tide

Watched, with wide starring eyes
Like a god of some kind, filled with pride
To observe a small town, being buried in snow
A joy, that no one denies

Yet sinister our thoughts they can dive
Imagining echoes and cries
Of those suffering within, trapped in the town
Drowned and buried, as snowflakes float down

But stop for a moment … think if you dare
What if you're in a dome, what if you're inside there?
But that couldn't be true, that wouldn't be fair
Yet if you found out you were, then indeed, what a scare!

You'd be trapped and unable to leave
No one would know, or want to believe
That a wish turned out wrong, was true all along
Which transported you inside, a small Christmas dome

See, you cannot trust Fairy magic they say
If you wish to be small, just like the Fae
For they'll make it so, but then covered in snow
You'll be trapped in a globe there to stay!

So take care when you shake a "Snow Dome"
Inside might be people, who knows?
But indeed most of all, don't make a wish to be small
You may end up where forever it snows

Each night repeated, the same as each day
In perpetual snowstorms, you're trapped in this way
In a blizzard you're cursed and thrown into the fray
Lost in miniature snow you will lay
All the people you know, will wonder "where did you go? …
… did they leave a note or just say?" …

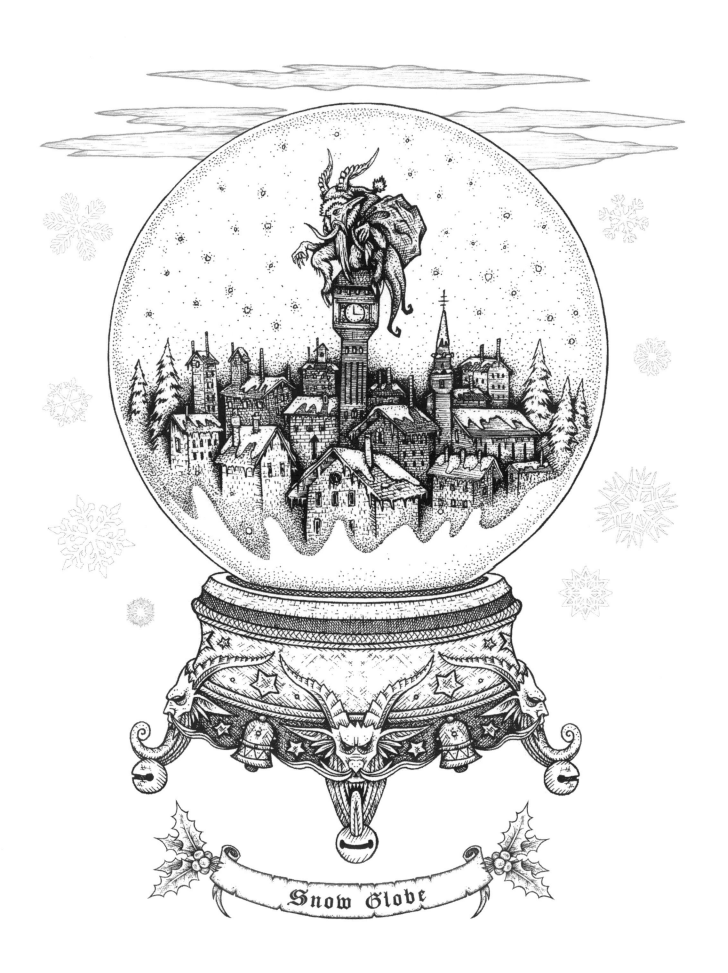

Snow Globe

The Snowmen

With coal for eyes and a carrot for a nose
These effigies are made from the things we have chose
Their spirits are trapped in the ice and the snow
Piled up into figures and adorned and bestowed
With hats and with scarves and branches for arms
Like scarecrows they stand in the fields and on farms

Slowly but surely they move if you look
For a real man or woman they're sometimes mistook
When seen at a distance, their arms wave in the wind
They're said to be occupied, by those who have sinned

The ghosts of the wicked, the forgotten and lost
Use the snowmen as bodies, made of ice and of frost
Like a golem of sorts we wish them to life
We dress them as people, sometimes Husband and Wife

Some give them a top hat, sometimes a pipe
Other features are made, with fruit that is ripe
With buttons occasionally used for eyes
Their creepy branch arms reach up to the skies
At night they can seemingly appear quite alive
Their eyes glint in moonlight, or as headlights drive by

Some build them quite large and others quite small
In the latter it's due to the lack of snowfall
The bigger they are, the longer they last
Though some will have melted next day by breakfast

Seeing them shrink, hunch over and crumble
We imagine with melted mouths they might mumble
Begging us—"please, don't let me die!" …
There's nothing we can do, except say goodbye …

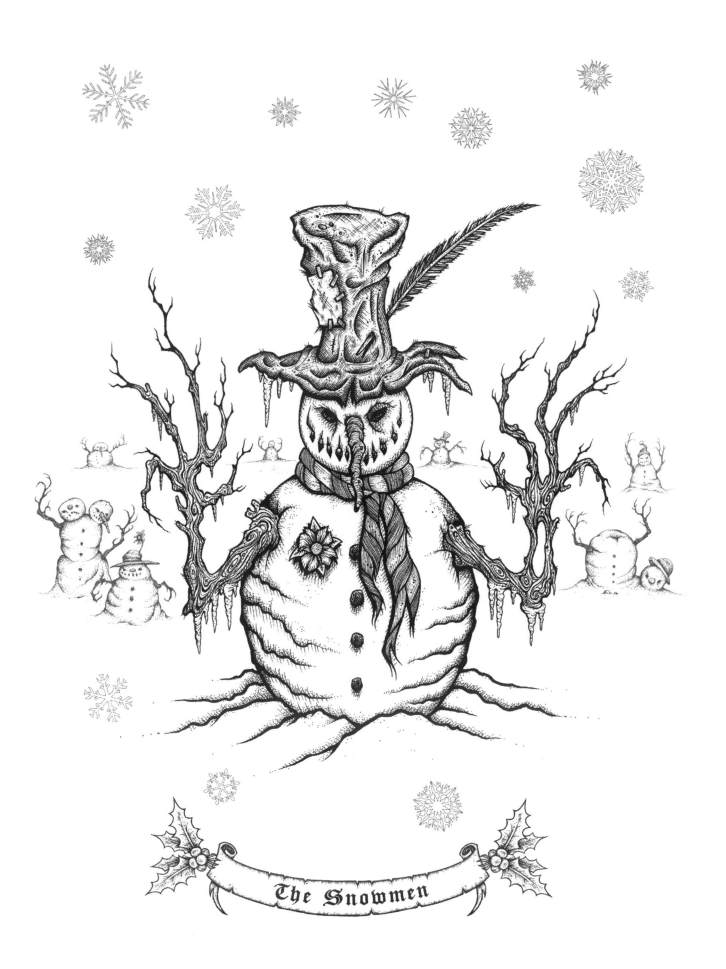

The Snowmen

Wendigo

The Algonquin speaking people of the North
On the coast of America and Canada of course
Most notably the Cree and also the Innu
As well as the Naskapi and Saulteaux too
All talk of a legend, including the Ojibwe
Of a winterland monster, that's really quite creepy …

It's known as the "Wendigo", thought once to be human
Though now supernatural, let there be no confusion
A ravenous, starving fiend of the snow
appearing emaciated, gaunt and hollow

Considered a cannibal, a man eater we're told
Like some miserable troll, it lives out in the cold
Regardless of how much this horror can eat
It's favourite of course, being fresh human meat
It remains to be starving and never gets full
With a skeletal frame and a face like a skull

Some say it can grow incredibly tall
Some tales tell of fifteen feet … perhaps more
Increasing in size with each victim it eats
Looming over the trees as it swallows the meats
But regardless, the ratio remains the same
It suffers with hunger, driving it insane

No matter how large this shape-shifter becomes
Forever starving, can't be much fun
Though do not take pity upon it too much
As the Wendigo won't hesitate, to eat you for lunch!

Like a banshee its screams are heard, far and wide
Through the mountainous blizzards, where explorers have died
Like a mourner it moans while it searches for people
It echoes through fog, like a bell in a steeple

You'd have better chances facing a bear
For this predator kills without care, so beware
If you wander off in the snow and the mist
You'll end up a statistic, unexplained and … missed

So be safe and stay home, don't wander alone
Or you may find you're the meal in the Wendigo's home.

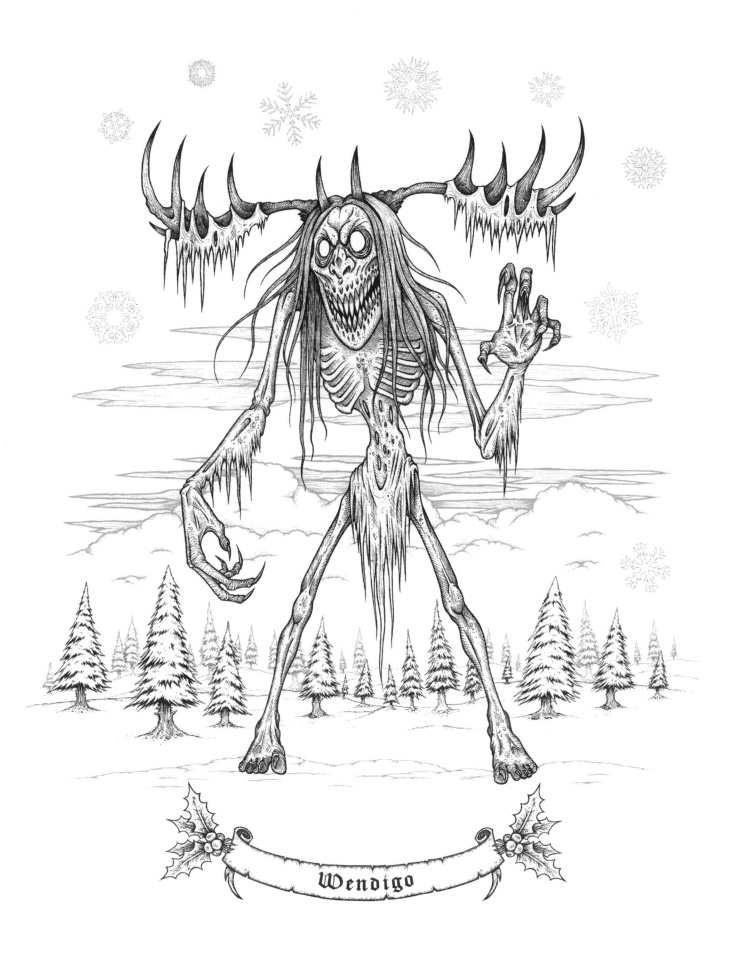

Wendigo

Mistletoe

With evergreen leaves and waxy white berries
Long fleshy stems evoke joy in those merry
For the thought of a kiss from a lover or other
Perhaps a new crush, with excitement you'll shudder

A symbol of fertility throughout the middle ages
The urge for kissing to this day rages

Though innocent and sweet as a kiss may seem
With good intensions and relationship dreams
The one you fancy and think is real swell
Considered the bees knees or rings your bell
Might not be all they appear at first
They could be a vampire with a parasitic thirst!

Believe it or not this plant is as such
Mistletoe's a parasite, on other plants it will lunch
It will drain their life force and without remorse
Feeding on their photosynthesis of course
The host plant will wither and die from such sapping
Whether a large tree or a bush or a sapling

In Victorian England tradition began
That any woman chosen could be kissed by any man
If she refused, bad luck would befall her
Like the vampire's curse, the juju immortal!

With each kiss until gone, a berry was plucked
Kissing beyond that was also bad luck

Kissing can be seen as the sharing of air
A symbol of sorts to give life and to care
But there are other thoughts to kissing, beware …

Some demons possess people in order to feed
And in much the same way, they infect just to breed …

Like the parasitic plant, face to face you'll be sucked
Haunted by horrible tongue ties you're struck
Perhaps with the same horrid partner you're stuck
As the contents of your stomach are brought up and are chucked
Upon realisation, you're totally … in a bad situation …

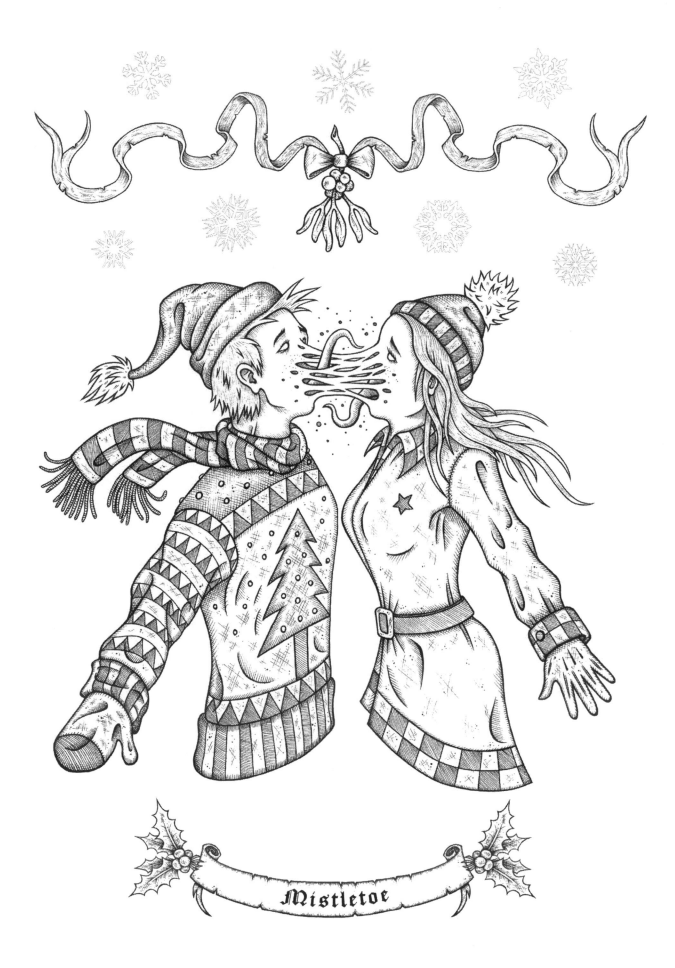

Mistletoe

Mari Lwyd

The Grey Mare of Wales from traditional tales
A zombie horse of sorts
Rising each winter in the deathly cold dusk
Would be accompanied by wassailers and other cohorts

These carol singers and mule, appearing each Yule
Would go door to door with song
In a battle to gain entry, for food and drink
Home dwellers would sing back to the throngs

When the residents backed down, drowned out by the sound
Of the hordes outside in the cold
The great stallion of death would enter it's said
Its companions were then fed it is told

This legend is performed each year by good folk
The spirit of the mare, they try to evoke
With a hobby-horse head, mounted up on a pole
They'd then dance and march, like the Pagans of old

Though some say this beast is of Christian lore
Its name meaning "Holy Mary" of course
At the same time others, will say it's much older
From supernatural tales of legends much bolder

This pale horse, this phantom, an image of death
A skeletal steed, a beast with no breath
A warning, a reminder, of little time left
On this earth that you dwell, to leave others bereft

So lock up your doors, your windows your gates
Pretend if you will, you're not home or in state
But know if you fool or try to avoid
This equestrian spectre doesn't like to be toyed
Haunted you'll be, even cursed just as well
For not facing the demon and its singers from hell
So be brave and sing back, stand your ground and be proud
Prepare for the worst by rehearsing out loud!

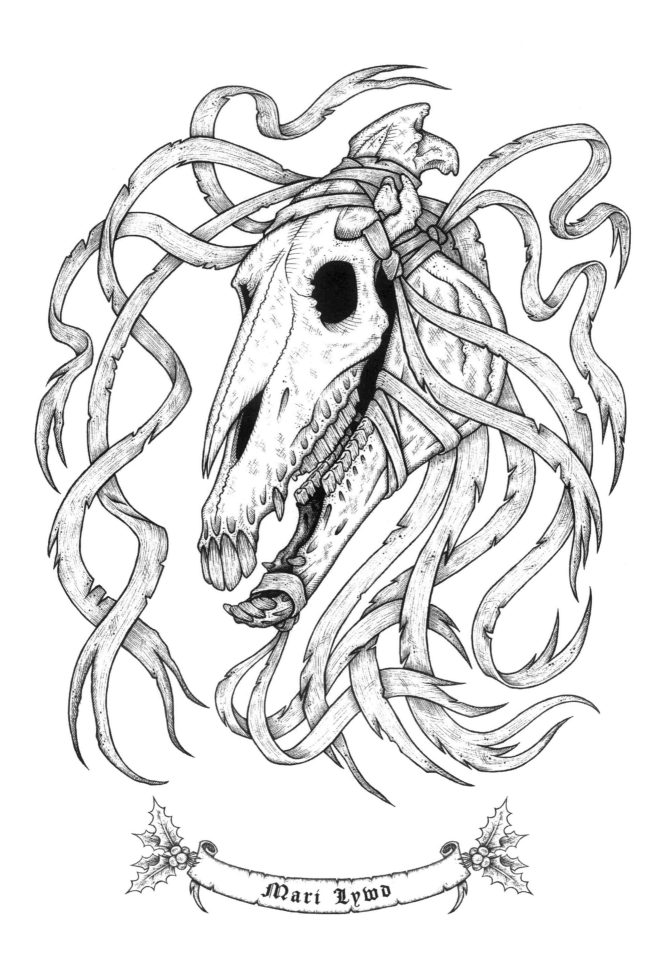

Mari Lywd

Gingerdead Men

Just like a golem, fashioned and baked
Little likenesses of people, men and women we make
With little sweet faces, we give them some eyes
A mouth made of icing and buttons or ties

Runaway food, possessed by a spirit
Sometimes a pancake, sometimes a biscuit
Causing havoc, disaster and grief
These horrible creatures, are worse than a thief

Leaping up from the oven tray, before they've cooled down
These critters cause chaos, all over town!
Running away, they shout, … "You can't catch me!" …
While under our breath we say— … "oh really?, we'll see" …

Most of these treats perform incredible feats
All avoiding the fate of being eaten like meat
They're often far chased, by both animal and man
They're swifter than you think, catch them if you can!

Now these dreaded breads can turn nasty it's told
In legend and folktales, these spirits are old
They await to inhabit a body been made
With care and affection, in the kitchens we slave

If chased for too long and not caught and then beaten
Perhaps not even by a fox to be eaten
The tables will turn and they'll blitz on their makers
The gingerbread bakers, their very creators

Some of these foods, roll rather than run
Consuming people, it seems just for fun
They'll eat the whole family, the Father and Mother
Then move onto the next to devour another

Some of them burst after eating so many
How is this possible? … your thoughts for a penny!
How could a biscuit, or small breaded man
Become a large monster, striking fear in the land?

The answer it seems is contained in the elements
The ingredients turn these small things, the size of elephants
From biscuit to behemoth, ancient magic's included
Yet no one will believe you, they'll say you're deluded!

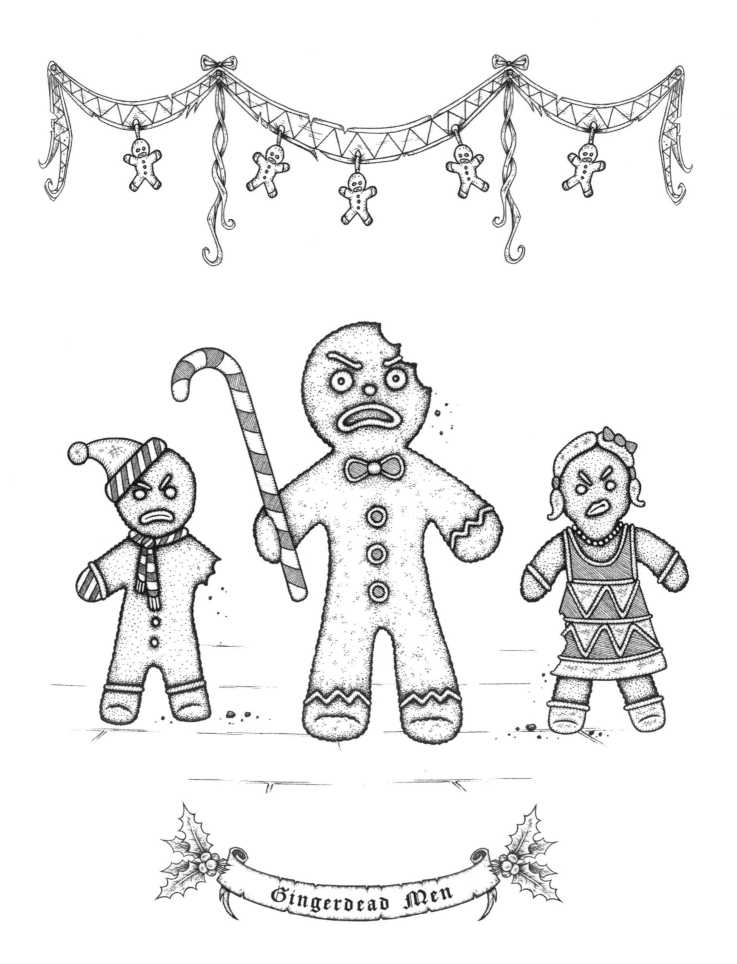

Gingerdead Men

Perchta

Some call her Berchta and in Russia Baboushka
In Italy she's known as La Befana
A goddess of Witchcraft, animals and winter
By many names through history we gave her

It is said that she leaves children cookies
In their homes as she seeks and spies
Searching each night, for the three wise men
On a broomstick legend has it, she flies

You see those three kings, those gifting things
Invited her to join on their quest
Too busy was she, sweeping and cleaning
She declined and now forever regrets

Portrayed sometimes, as really quite beautiful
A queen of snow and ice
But really her true form, it is believed, isn't actually all that nice

A Witch is she, half woman, half demon
With one of her feet, of a goose!
A sinister being, a crone, a hag
But something far from a recluse

It is written that, she'll leave you coins
Silver, by your bedside
This is of course, if you've been good
If not, you'll soon surely die …

She'll creep upon you, as you sleep unaware
Of her tattered old clothes and her straggly hair
She'll slice open your belly, pulling out your guts raw
Replacing them with pebbles, some trash and some straw

She's accompanied by the Straggele
A horde of horrors with horns and hair
These demons will tear naughty children apart then toss them up in the air!

To appeal to her good nature, an offering can be made
By leaving goose fat, in a pot outside - from her wrath, you may then be saved
Witches rub it on their bodies, as it enables them to fly
So cook a goose for Christmas, unless you want to die!

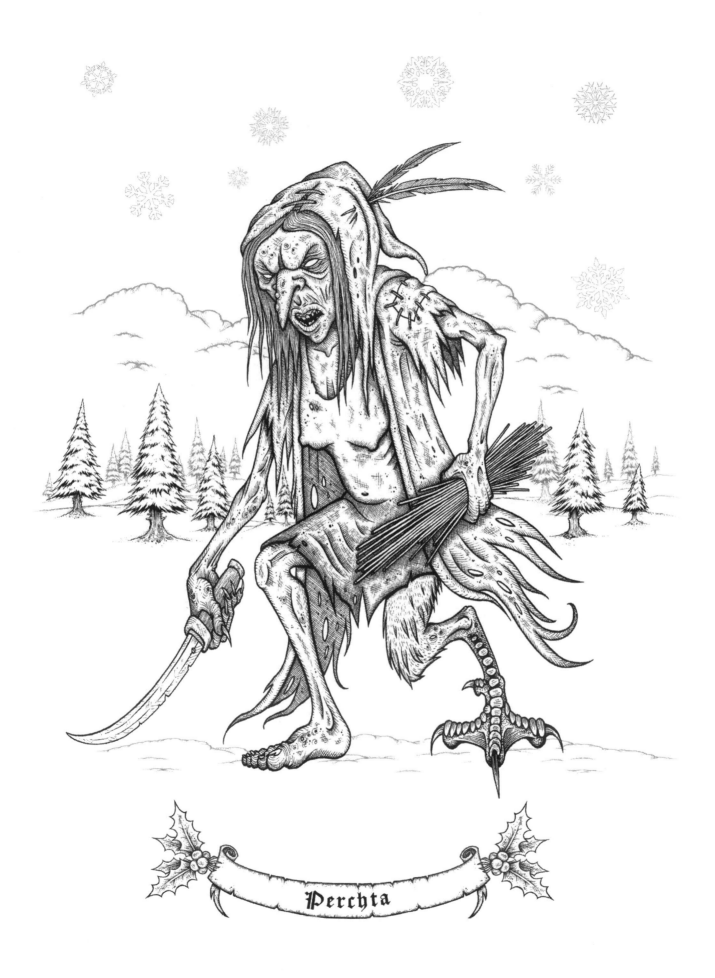

Perchta

The Snow Bear

In the land of ice and the deepest of snow
Where the winds can freeze and the northern lights glow
There lives a beast of incredible size
Like the Grizzly his shape is of a similar guise
Their territory spreads throughout the polar region
With the winter chill, a perpetual season

The largest of their kind, not in legend nor folklore
This creature by fact, the largest land carnivore
Bigger than the Kodiak, though not by much
They're considered the biggest and hold the title as such

Of five hundred kilograms, the males weigh just shy
Though these majestic snow elders are really quite spry
Standing ten feet tall, upon their hind legs
How they don't break the ice, the question it begs

Upon first glance they are white
Their eyes and claws black as night
Their fur traps reflections of the snow in the light
Which gives them the shade that appears to be bright

But in truth their hairs are just hollow
Now stick with me here, try to follow
The science itself, involving spectrums of light
Is something I'll get back to tomorrow …

Their scientific name, "Ursus Maritimus"
Meaning the "Maritime Bear"
Though most born on land, it's the sea of ice
Spending most of their life, is out there

Hunting for seals, makes up most of their diet
For the majority of their lifespan
They're also known, on occasion it's told
To have quite the taste for man

A strong instinct to feed, their main focus and drive
To bring down as much prey as they can, so to thrive
Vast snowfields they'll walk, as they continue to strive
Over deep oceans they'll swim and they'll dive
They don't care if you have children, or for husbands or wives
They won't kill you if they catch you … they'll eat you alive!

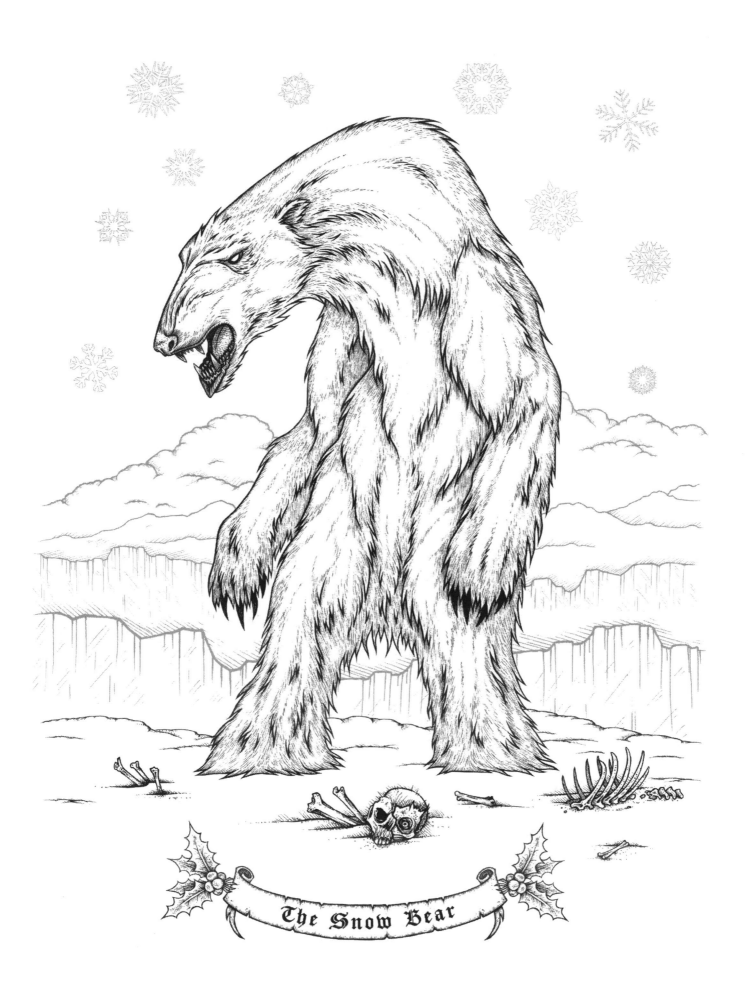

The Snow Bear

Chingle Bells

The bells, the bells, the bells
When rung in succession their vibration swells
Through walls like ghosts, their presence is felt
A madness is caused, insanity dealt

Ringing alarms, calling to action
Raising song and good cheer
Bringing together the many flung far
Hypnotically chiming … "come here" …

No matter how deep or thick the fog
In winter the bells can be heard
Their power, their magic, their supernatural calling
Quickly gathers the herd

No matter the size, shape or tune
The ringing of bells can dispel certain gloom
Certain of course, meaning some, not all
For there are of course bells, whose death toll is called

For whom these bells of passing ring
Encourage those who remain, to sing
For in the darkness a greatness dwells
An evil force, older than Hell

Good cheer must be made, noise and song
Be sure to join in, not before too long
To ward off the creepy creatures who wait
Who feed off those filled with cruelty and hate

A swing then a ding, a boom then a ring
These metal monsters through bone they can sing
With every strike of their hammer and tongue
They ripple the air, in their swaying throngs

Some found in churches, in towers up high
Such bells are impressive, you cannot deny
Some hang around goats necks, clanking with a ting
Appropriate tones for the tunes that they sing

But the sound of bells with the clinking of chains …
Is something to be wary and fear
If you hear such a thing, in the darkness of night
It means that Krampus is near!

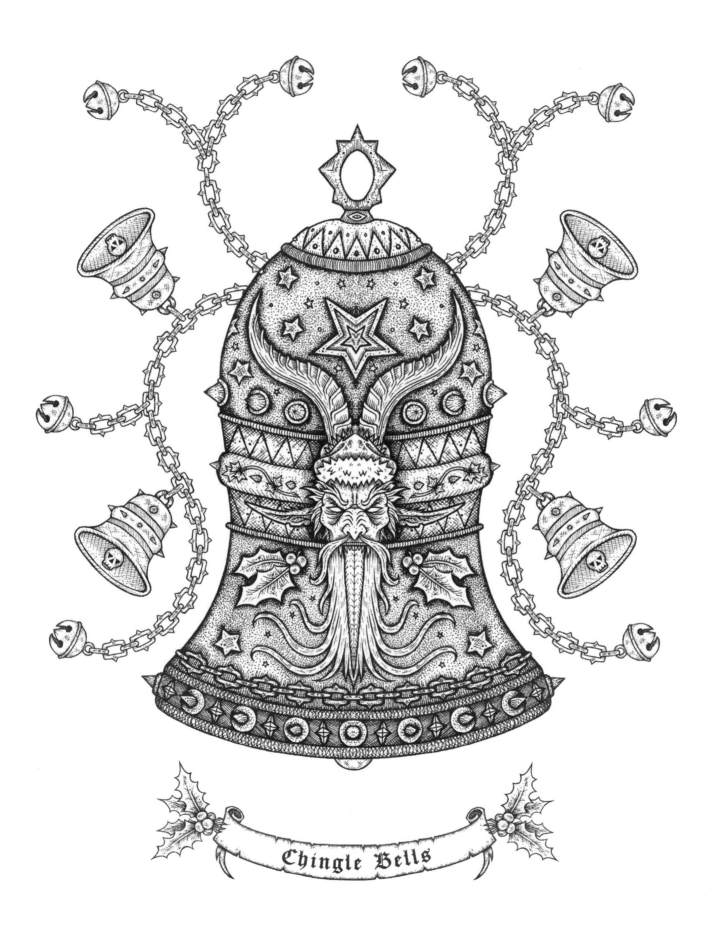

Chingle Bells

Rabid Rudolph

Legend speaks of deer so great
Who aided Santa, so as not to be late
This little beast, a sort of runt
Was often bullied and got the brunt
Of all the jokes and all the hate
For all the pranks, he took the bait

One foggy night, as the story goes
His snout glowed red, brighter than a rose
Through thick fog, he lit the way
Leading the other reindeer, pulling Santa's sleigh

For this act he became a hero
No longer the loser, no longer the zero
The other deer, who pulled the sled
They showed respect, so it is said

But little did they know that night
That Rudolph had sustained a bite
From a rabid bat their sleigh flew into
None of them noticed, none had a clue …

Rudolph of course felt the biter
Which made his nose glow ever brighter
He raced on harder, through the pain
Through sleet and snow and freezing rain

He was accustomed to what was cruel
He used the pain just like a fuel
Delivering gifts to girls, boys and babies
No one knew Rudolph had rabies!

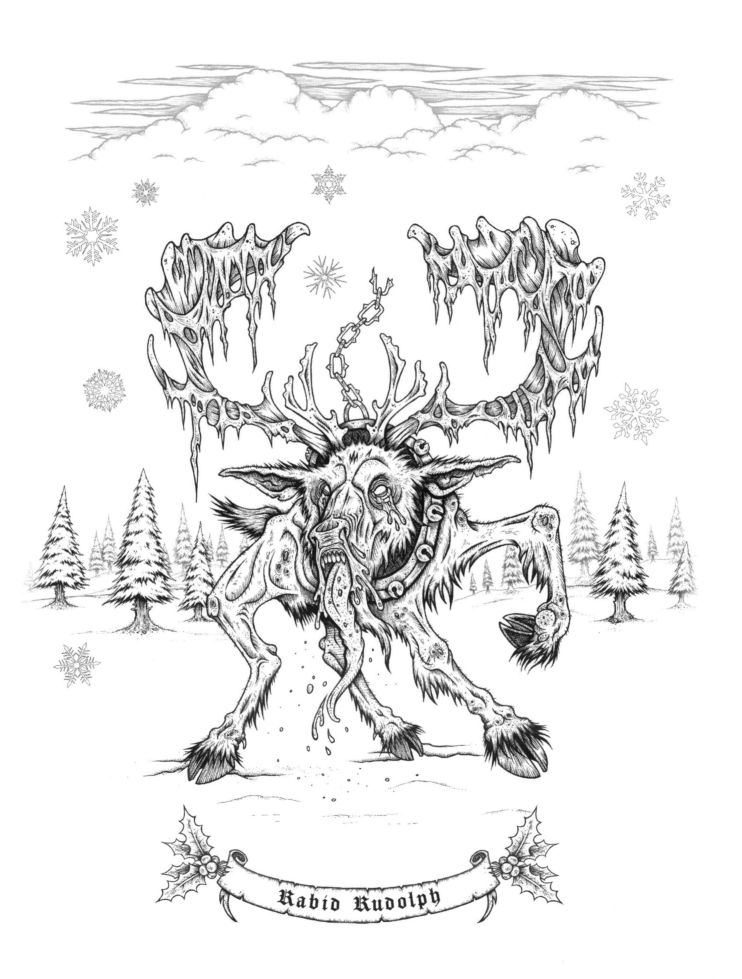

Santa Claws

Old Saint Nick or Father Christmas some even call him Kris Kringle
Santa Claus or Sinterklaas and other strange name jingles
Some think of him as Odin, father of the mighty Thor
Others call him the "Christmas King" of ancient folklore

A mythical figure with origins unclear
On December 24th, his mission each year
To bring gifts to children, the ones well behaved
A list of those naughty and nice he has saved

His wild hunt, a procession, across the night sky
In a sleigh he is pulled by nine reindeer who fly
Dasher and Dancer, Prancer and Vixen,
Comet and Cupid, Dunder and Blixem …

Rudolph of course at the head of the team
With his nose so bright like a beacon it's seen
Through fog and through darkness without fail they take flight
Dancing and diving in the ocean of night

With ancient magic, conquering time
Down chimneys the world over, Santa will climb
Delivering gifts to all those who are kind
Under the tree, presents they'll find
Answering wishes and prayers of the good
Gifting only the behaved, must be understood

To those who are naughty you might get some coal
Or worse still, Santa's dark side unfolds …
If you sneak down at night and try to spy
Or interrupt his cookies and milk, say goodbye
For he may eat you up and think you're a meal
You might find yourself taken, in his sack he will steal
You'll be taken away and turned into an elf
Best stay in bed and just wish him good health

Leave him a note, perhaps a glass of sherry
In order to fuel this jolly man's big red belly
Then jump into bed and assure him with snores
That you're not peaking in, or he'll snatch you with claws!

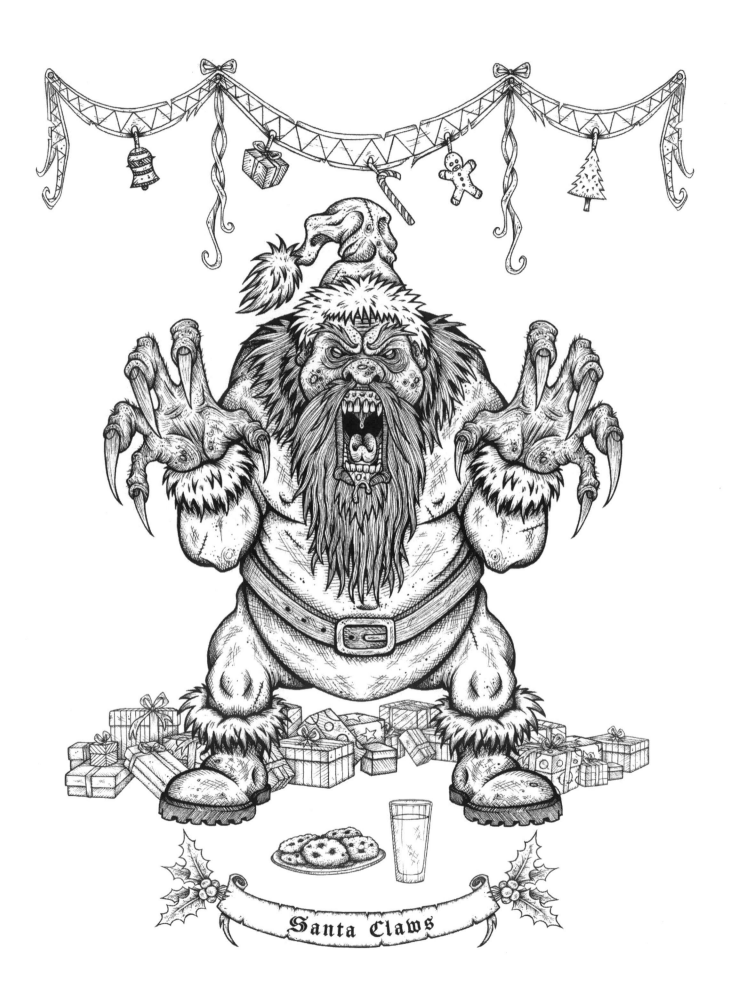

Santa Claws

Candle Fright

In ancient times during winter solstice
Candles would be lit in celebration
Not of the cold or the praise of the chill
But that spring would return soon, salvation!

"The Light of the World" a Christian title
Given to Lord Jesus Christ
A symbol of hope and of love and of warmth
To survive the harsh winter nights

Representing the star of Bethlehem
The candle was seen in this way
Held aloft by wassailers, (carol singers today)
By this light they would wish and would pray

Lit in order each night, through the Jewish festival of light
In a menorah they sit, with nine branches they're lit
For the eight nights of Hanukkah, so tradition is writ

The ninth holder's known as the "shamash"
The "helper" or "servant" its role
To light the other candles and act as an extra
Its main purpose, purely just sole

"Menorah" is Hebrew for lamp
The world over, considered the champ
The largest of which there are two
Found in New York City, it's true
Standing thirty two feet, you need a crane to light these
One in Brooklyn and Manhattan too!
But not all of these flames light the way
Or give solace to those led astray
Other candles it's told, invoke those that are old
Ancient spirits of night, not of day

In ritual some use thirteen, to call beings from shadows unseen
Often lit to give light on the darkest of night
To things born from our nightmares not dreams

But when lighting these long sticks of wax, look out for two hoof-prints in tracks
For if walking like man, you'd better run if you can
After that, then there's no turning back!

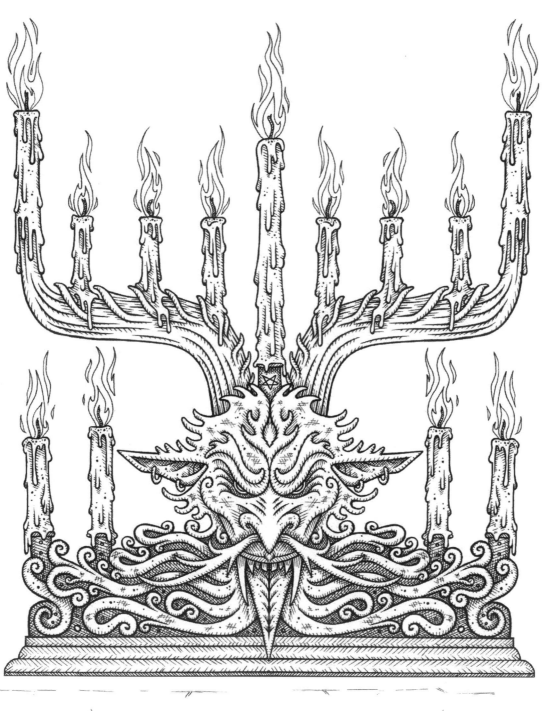

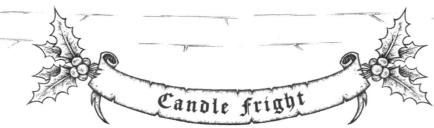

Candle fright

The Grimace Tree

An evergreen conifer, spruce, pine or fir
When decorated with baubles can cause quite a stir
Trimmed with ribbons or tinsel or twine
A dressed up tree can look mighty fine

An angel or star placed on top of the tree, perhaps a nice bow, but nothing too twee
Can be quite a lovely finishing touch, though some people think that these things are too much

Originally apples and nuts would be hung
From the branches along with small treats would be flung
Sugar ornaments and candles and even small gifts
Such a tree as adorned would give you a lift

It would light up the room with a magical glow, twinkling Christmas lights became part of the show
Beneath the tree were placed many presents, but for the longest time, wasn't practiced by peasants

The origin of choosing a tree for your home
Dressed up with ornaments as such isn't known
But the practice was active and performed with loyalty
After being passed on to the public from royalty
Starting firstly with those higher European classes
This tradition became popular and spread through the masses

Though bringing a piece of the wild inside, sprucing it up and decorating with pride
Must be given some care and the deepest of thought, when removing a tree from a forest to flaunt

The spirits of nature, those ancient protectors
The fae-folk, the nymphs, the sprites and the spectres
Inhabit the woods, of which they call home
If removing a tree, don't go there alone

Be careful which tree you are going to choose
Make sure it is nobody's home you remove
For the fate of your actions will surely prove
When they climb through your windows, sliding in from the rooves

If you've gone to the forest with an axe to attack
To take down a tree with an almighty whack!
They'll follow you home, they'll follow you back
They'll come in through the keyhole and chimney stack

Some spirits will possess the very tree itself
They're not physical like a troll or even an elf
Instead like a demon, invisible and free
They'll transform your prize evergreen, into a "Grimace Tree!"

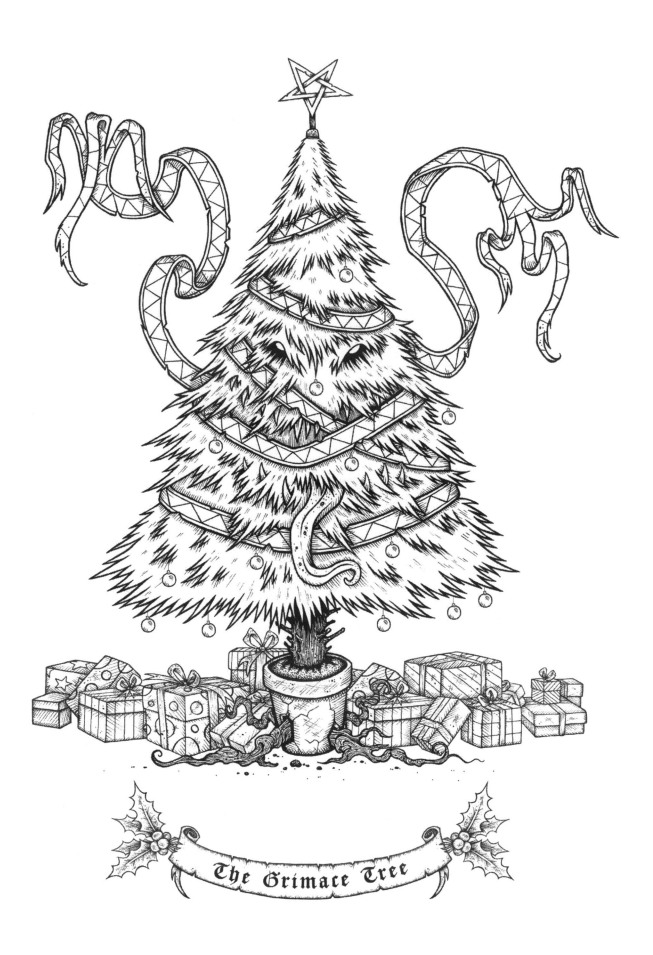

The Grimace Tree

Winter Woollens

In the season of ice there's nothing as nice
To be gifted a woolly jumper, hand knitted, you can't price!
In the United States, they call them "sweaters"
Keeping toasty and warm, there is nothing better
On a frosty night, all cold and chilly
To go out without your woollens, is certainly silly

Often knitted by the elderly, usually a gran
Perhaps a great aunt or sometimes your nan
These jumpers and sweaters became popular fast
In the 1980's their favor would last

Knitting needles were twitching, as each thread was cast
As the want for the woollens, took off with a blast!
Of traditional past they were patterned with pictures
Snowmen and snowflakes, Christmas trees made of stitches

Thanks to television hosts, across the UK
Up until the 1990's, these woollens would stay
But then something happened and the view it did change
People thought them quite ugly, distasteful and strange
For a spell of ten years, the jumper was hated
Often used as a joke, with the thanks quite belated

An unwanted gift, the sweater became dreaded
The worry each year of what Grandma had threaded
Though worn with reluctance, so as feelings weren't hurt
Obliged to be thankful for all her hard work

Wearing unwanted woollens was waning
As the knitters got wind of their loved ones complaining

Though mittens and hats and scarves and woolly caps
Were by common sense, still badly needed
The request for such gloves and snugly socks loved
In the minds of designers became seeded

People became proud to wear such woollens
With new jumper designs in fruition
The ugly sweater became popular again
Even now there are held competitions!

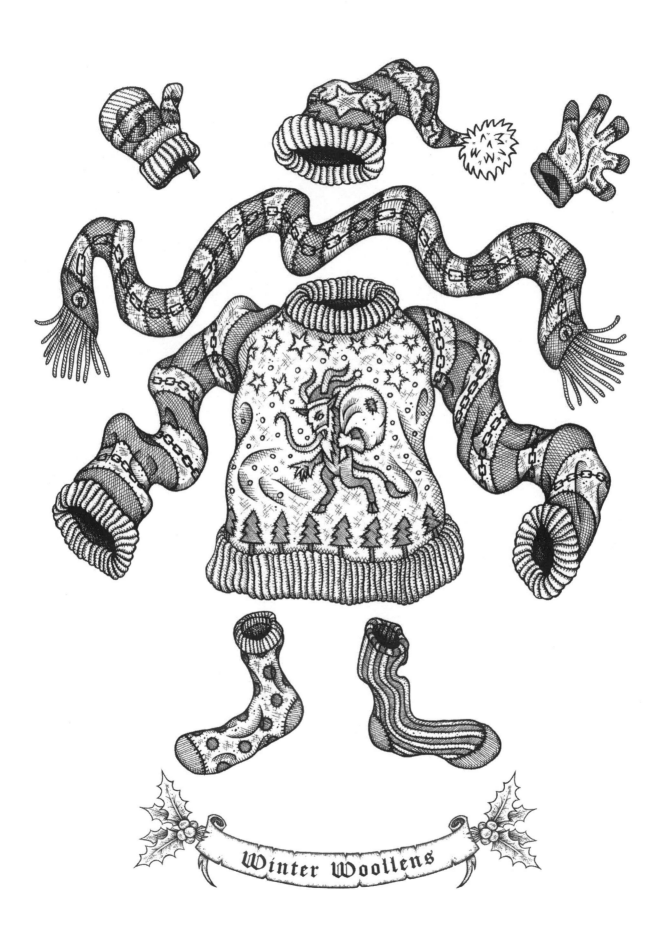

Winter Woollens

Elves

Santa's little helpers, in every sense but with reason
Build toys for the good kids, torment the bad in this season
They tend to the reindeer, they polish Santa's boots
But with goblins and gremlins they're also in cahoots!

They crawl down your chimney, they check if you're sleeping
A fright you'll receive, if caught spying or peeping
They'll bite at your toes and claw at your ears
Santa's Elves should be always, revered and feared …

If you behave and are all nicely tucked up in bed
Then you've nothing to worry about, in your little head
They'll leave you alone and they'll get on with their work
But if you step out of bed, their ears they will perk!

For the most part these fae-folk, who live at the North Pole
Are nothing to worry about, as they have their own goals
Their jobs are quite simple and they obey Santa's orders
But occasionally there are bad ones who act like marauders

They'll stow away in your house after Santa has left
Often throwing out presents causing blaming of theft
They'll break toys that aren't opened and gifts wrapped up tight
These occasional mischievous creatures aren't nice

They'll eat all the chocolate and all the nice food
If your household is miserable, they will sense that mood
They'll make things far worse and will stick around 'til dawn
For the elves that sense sorrow, from hatred are born

The sunlight will kill them and they'll crumble to dust
But on Christmas Eve you must behave, you must!
These sprites, these goblins, these gremlins, these imps
Know if you're trying to catch a quick glimpse …

The good elves aren't going to stick around and help
They're loyal to their master, Santa, "The King Elf!"
So before you think about creeping downstairs
Take a moment, consider the elves and beware!

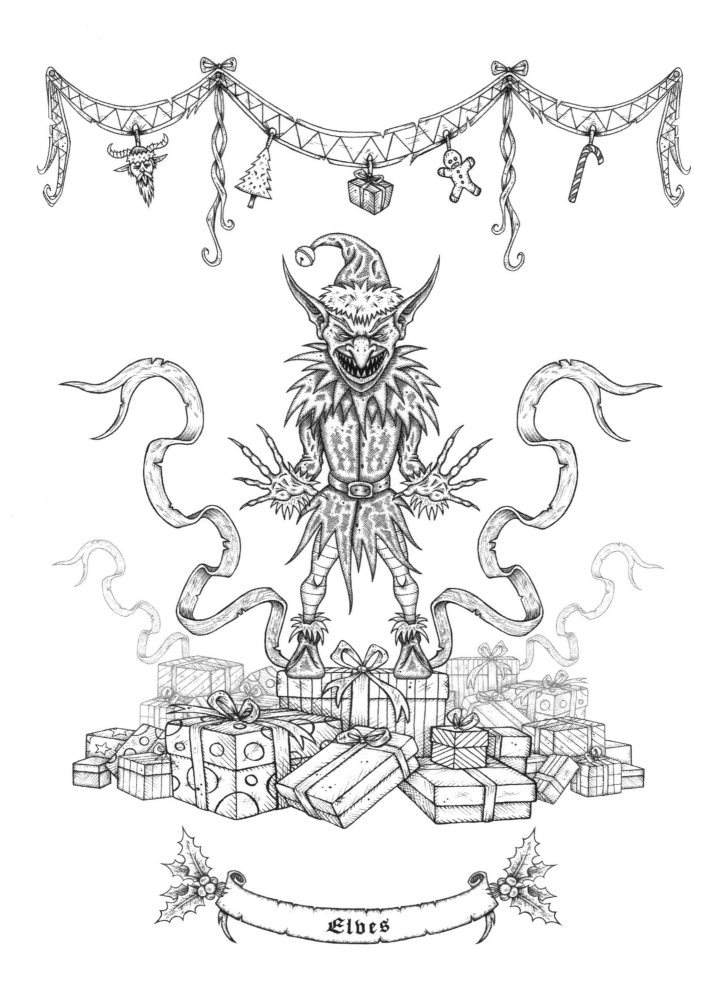

Elves

Candy Pain

Folklore speaks of an inventive choirmaster, in Germany long ago
His sweet thinking and warm natured heart, it's thought
Could have melted the deepest of snow …

Long sticks of candy, were handed out to children
To keep them quiet in church
For their noise on Christmas Eve, it's said
Was quite simply the worst!

So made to represent a shepherd's crook …
(A long pole or staff and at the end a curved hook)
Christmas Eve, the choirmaster, gave these sweets out
In the hopes that the children, didn't scream and/or shout

The "crook" itself, a symbol of control
But also of care and protection
Against those who would prey, upon the sheep
It was also used as a weapon

The red stripes they say, represent the blood
Of Christ, the holiest of shepherds
But of many colours, candy cane can be striped
Some can even be spotted like leopards!

Though care and protection, is indeed the theme
When it comes to candy and health
Too much of this stuff, will of course rot your teeth
They'll shrink away, in a way, like snowmelt

But you might even suffer worse luck
If you chomp down too hard on this stuff
Your teeth could just crack
Or fall out, just like that
Trying to eat these boiled sweets is quite tough

Akin to a kick in the mouth
From a horse, your teeth would go south
Biting hard on this rock, is not something to mock
As your smile would be the joke of the house

So instead then just lick, on the candy cane stick
Sucking on them, they last longer too
But don't eat too many, else they'll make you quite sick
Either way, your teeth are plain doomed!

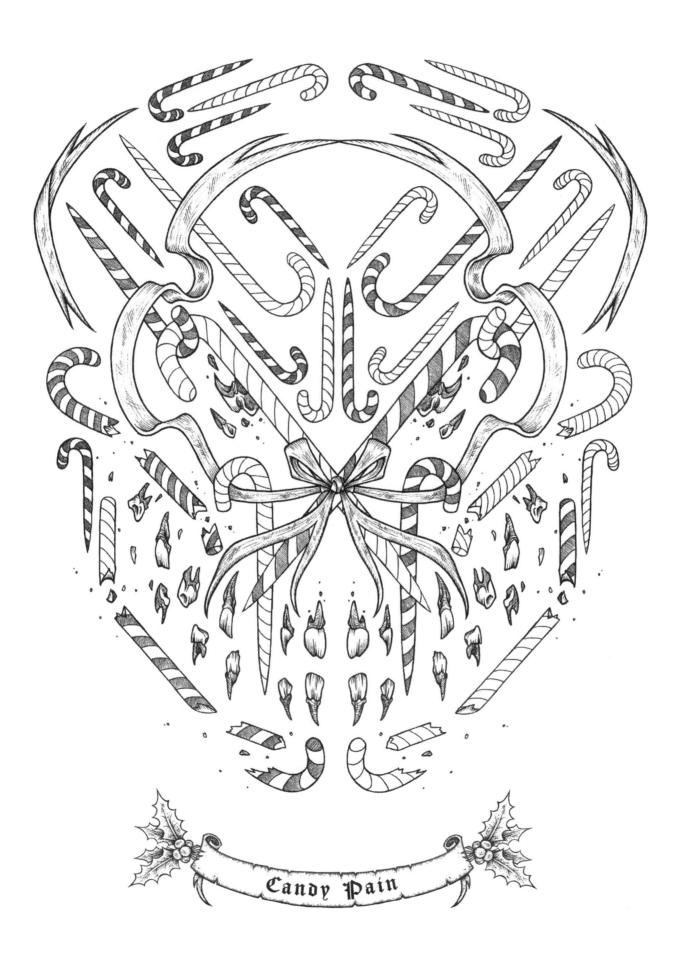

Candy Pain

Presence

Giving gifts each year to bring happiness and cheer
Is a practice whose origin, truly isn't clear
Some say it stems from the Christian faith
Though of other religions, this can also be traced

Gift bringers are believed in, from every land
They have many names and helpers at hand
Some wish to "Santa", others to "God"
Some really don't care where their presents are from

So here lies the problem, when gifts are concerned
It's better to give than receive, it's been learned
Though there are some, who just take and are greedy
They expect and demand and are horribly needy

These gluttons of getting, of "must have" and "want"
Are often forgetting and go off on a rant
That it's not about what you might get or you need
If continued this way, an evil will seed

Instead it's been said to be thankful and happy
Whatever received, even if deemed quite crappy
Put on a smile, give a hug and say thanks
It's the thought that counts, not breaking the bank!

Also remember, on a serious note
A pet isn't for Christmas, especially a goat
People give puppies and kittens too
But really this act is terribly cruel

For after the Christmas season is done
The novelty pet is a burden, then some
Expenses and training, perhaps even repair
To your shoes or your couch or your favourite armchair

Quite often these pets are given away
Some are destroyed or left out to stray
So think twice before gifting a pet like a toy
Regardless of the smiles, laughter and joy

Instead perhaps gift, on a snowy Noel
A presence called up, directly from Hell
That is if you're a sucker, for mistakes and mess
By all means, raise a demon, that's no end of stress!

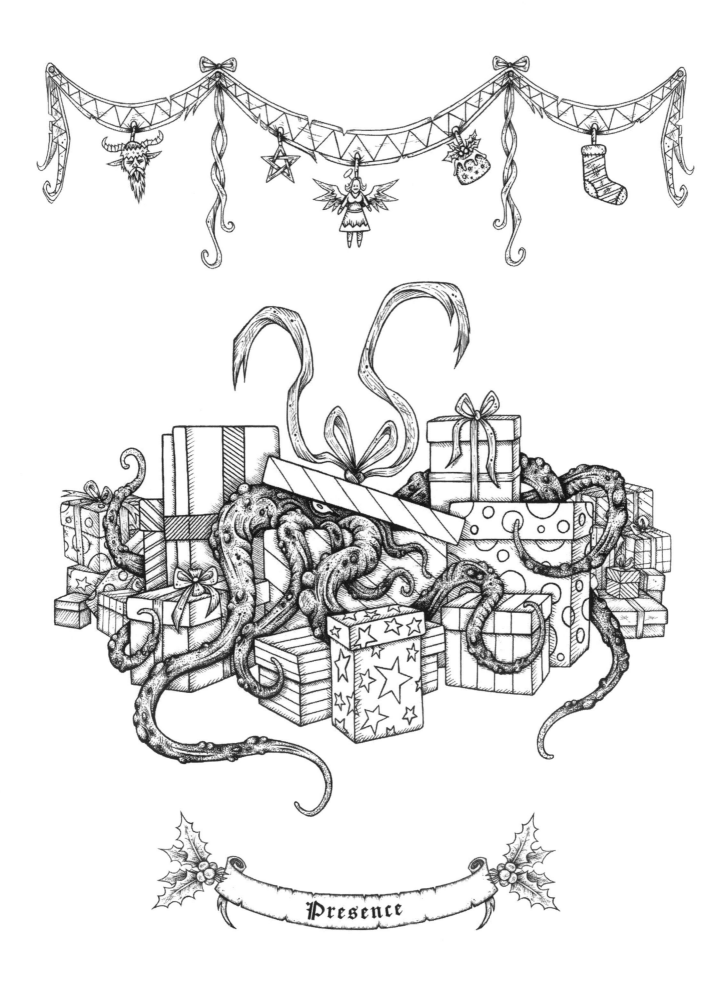

Presence

Christmas Mourning

The holiday season at the end of the year
A time to reflect, not just celebrate and cheer
A thought must be given to those who have gone
The ones who have past, whom we'll join anon

Family members, friends and lovers
Furthermore buried by deepest snow cover
Should be given a thought, when the cold sets in
As the season of winter starts to begin

Those we have lost, who've been taken away
Whose life's been cut short, deeper missed by the day
Should be remembered as though, they're with us still
Not left in the cold, outside in the chill

So invite your ancestors, call to the dead
Ask them inside, it's often been said
By spirit board or séance, Necronomicon be read
To your front door, may the lost souls be led

Now raise a warm toast and hold high your own glass
To your family who've fallen, they won't be the last
Wish not that you're next, or any time soon
Or with death you may dance to an untimely tune

So visit their resting place, or just give them a thought
Remember their stories and all you've been taught
Not paying respect, or credit due, counts for naught
In the end your own family history distorts

Be sure to remember, all those we have lost
Don't let them fade, in obscurity tossed
If you move on without them, they'll turn in their tomb
Eternally lonesome, forgotten in gloom

Life is too short as it is to be down
To sink into sadness for those underground
Instead be glad that we knew them and smile
The grief of them gone will lift after a while
Replaced will be thoughts of genuine good cheer
Remembering those, who we wish were still here

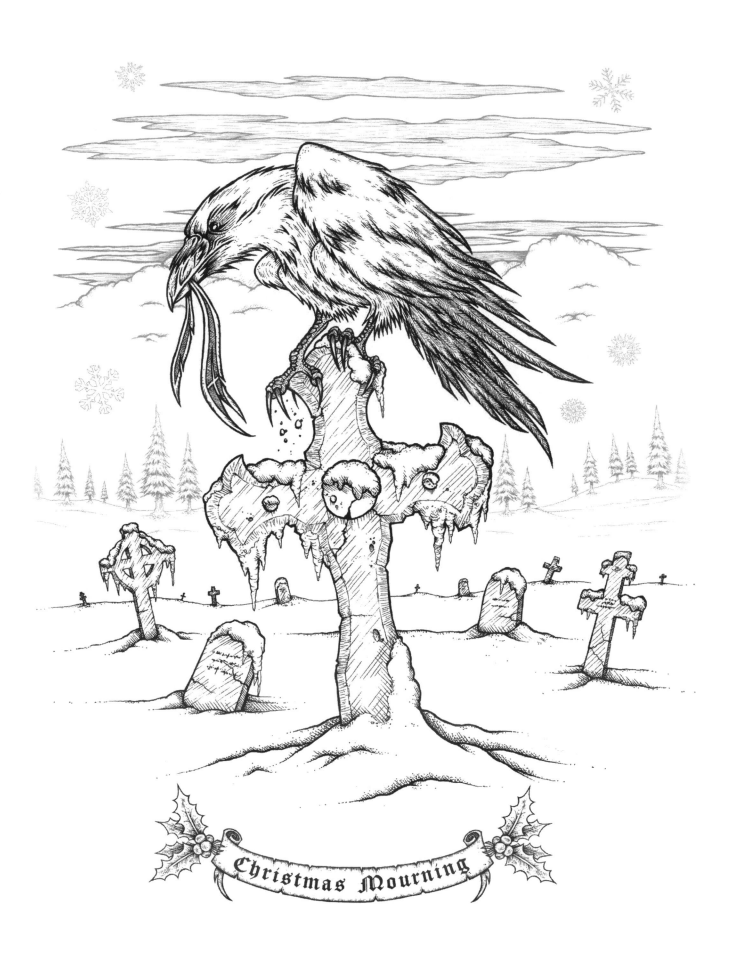

Christmas Mourning

Toys

To the young and the old, to both girls and boys
Gifts are given in the form of toys
But also toys are given to pets
Perhaps a reward after visiting the vets

The origin of the word "toy" is unknown
Since prehistory they've been used to help the mind grow
Representing animals and people as tools
Toys can be found, both at home and in schools

Though sometimes, just sometimes
These effigies are made
Not created to free minds, but instead to enslave
Sometimes used to control, or cause pain in another
To seek vengeance perhaps, on an oblivious ex-lover

The voodoo doll can be used in this way
Causing physical pain and mental dismay
When stuck with needles or given a burn
Leading to torment and grave concern

To harness a spirit or soul in a toy
Is something not intended for joy
Some use this act to keep people safe
From a spectre, a demon or some other nasty wraith

But some hide this evil in toys to disguise
Their location, their vocation a frightful surprise
Sometimes sent as a gift, brightly colored and wrapped
Yet inside these evil spirits are trapped

If attacked by a toy in the middle of the night
When the hour strikes three and they come to life
Be wary of breaking the toy to make peace
For instead a great demon or beast you'll unleash

Simply keep at arm's length and box it up nice
Then leave it to freeze outside on the ice
A passerby, may pick up the package …
One can only hope
Though guilty you may feel for this
To keep it, the answer's "nope!"

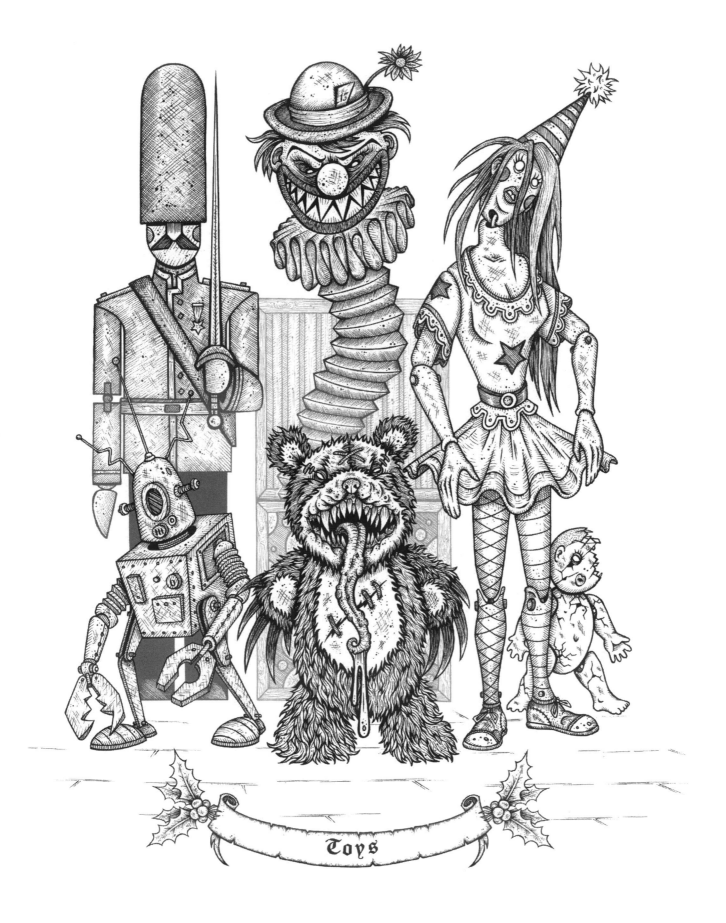

Toys

Canis Lupus

The big bad wolf, the wolf at your door
The warrior, the devil and so much more
These beasts have been feared and revered in many ways
In folklore and fairytale of olden days
Through myth and legend, religion and faith
From the howl of the wolf, no one can escape

From Native America to the Norwegian range
In various tales, supernatural and strange
From Little Red Riding Hood and The Boy Who Cried Wolf
These fables will grab you, imagination engulfed!

Through fantasy and adventure these hounds can be found
Through hell and high water their existence still bounds
Persecuted by man as a predator and hunted
Their world domination, was far from stunted

Feared throughout Europe and Asia as much
Seen as force of darkness and such
The lapdog of Lucifer, the canine companion
Legend speaks of a wolf, the size of a stallion

In Norse Mythology, "Fenrir" was his name
A mighty wolf contained with huge chains
The lore was told, that if he broke loose
The sun he would swallow and the moon he would swoon

In "Ragnarök", from Norwegian myth
This monstrous wolf of the apocalypse
Was said to be the death of the great Odin
This figure to some, considered Santa, was stolen
Then into death the Norse god was thrown
A place of great darkness, the world would be known

The legends live on in various forms
In a number of cultures, wolf skins are worn
To invoke and become, like shape a shifting demon
With legends of lycanthropy in the winter season

The Native Americans refer to "Wolf Moon"
In January skies, when the winter's still cruel

In the season of ice, one thing can be sure
There might be more than a wolf at your door

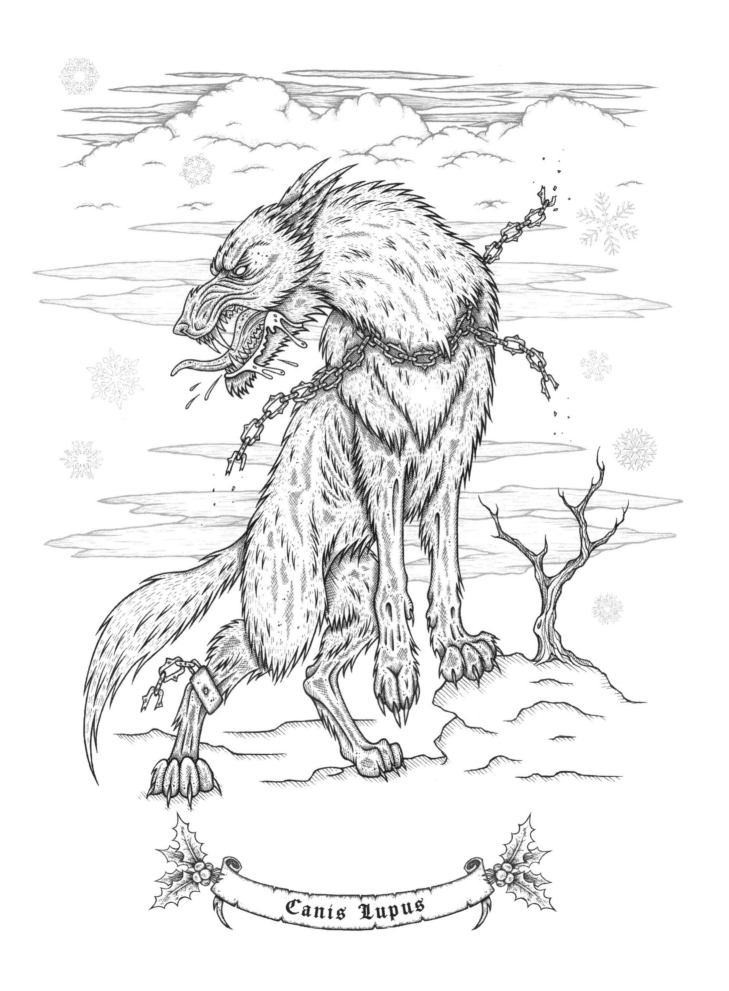

Canis Lupus

Unicorn of the Sea

Known as the "Narwhal" or the "Narwhale"
This ocean dwelling mammal, has an interesting tale
For once it was believed that this beast was a myth
Told to have had a quite magical gift

Such joy and delight upon sight of its horn
Believed to belong to a unicorn
Presented to kings and queens as a prize
Their true origins of course, were simply just lies

Like dragons teeth and claws, with their great treasured bones
These horns were sometimes made, into great Royal thrones
Carved and arranged to be admired by all
Some are said to have measured more than ten feet tall

Thought to have cured, depression and woe
Neutralising poison, another lie that would flow
Vikings would trade them, with more value than gold
Four times their worth in weight it was told

Queen Elizabeth the first, was presented with such
A tusk bejewelled of great worth
Given to her by Sir Humphrey Gilbert
Said it lived in the sea, not on earth

He called it a "Sea Unicorne"
The same value as her castle, its horn
But from this strange creature, this cryptid of sorts
Still a great many legends were born

But of course over time, explorers soon learned
This horn was in fact just a tusk
From a somewhat small whale, from the Arctic realm
The truth would cause them to "tsk-tsk!"

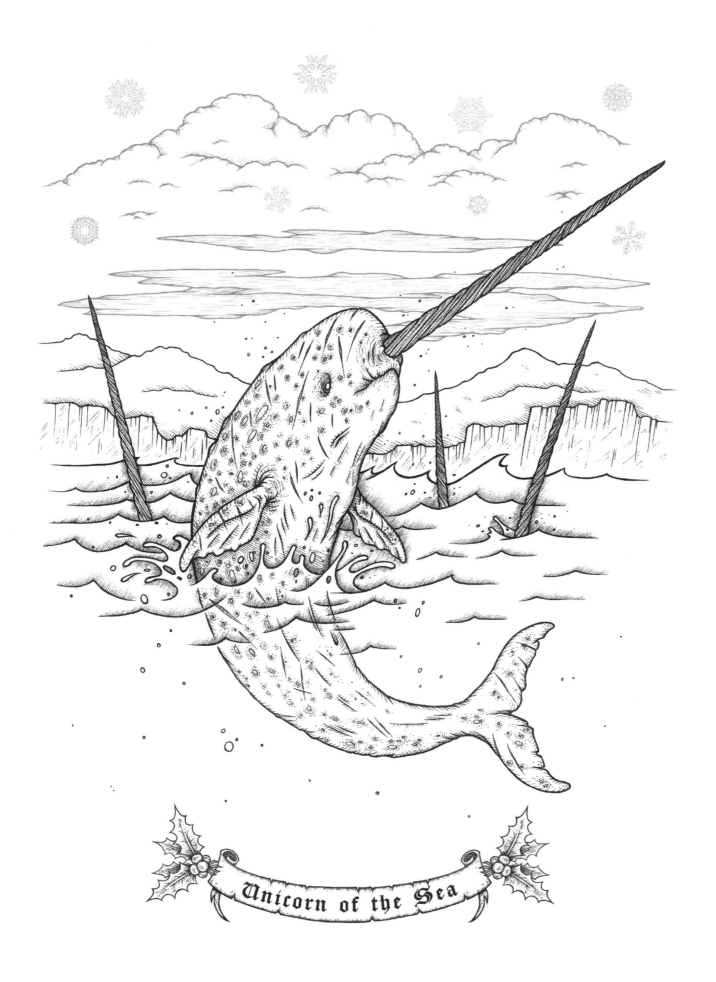

Unicorn of the Sea

Crackers

Tom Smith, Inventor, Englishman, a seller of sweets and treats
His bonbon selling artifice, became something rather neat!

Originally made to contain the sweets, those round and powdery orbs
A promotional idea, like a fortune cookie, was very much adored
Inside the twisted paper, a message of love was wrapped
But from a crackling log observed, a new idea was hatched!

As the log popped and fizzed, then gave off a "crack!"
The inventor of the Bonbon wrapper decided this they lacked
Adding to the package, a mechanism to make them bang
The tube itself, became so large, to pull you'd need two hands

So large became the wrapper then, so as to house the trick
The Bonbon sweet itself thrown out, then bore a new gimmick!

The name now became "Cracker" after pulled apart would sound
With those quite fearful of the bang … (in truth it is quite loud!)

Pulled apart at the table, during Christmas dinner
For the contents held within, there is but just one winner
These brightly wrapped cardboard tubes, enclosed trinkets quite little
Perhaps a toy or model, also a joke or riddle

In addition to all this you'll find, sometimes elastic bound
A brightly coloured paper hat, resembling a crown

Now wearing festive hats of course, dates back to ancient Rome
A time when sacrifice was rife and celebrations thrown
Today our winter season lacks the horror, if we're lucky
But occasionally something does occur, that is indeed quite yucky

The "Christmas Cracker", a novelty, enjoyed by young and old
These things today are factory made and horrors can unfold …
As urban legend speaks of workers, often losing digits
Unwilling sacrifice as such, the thought will make you fidget

There's a story of a family, at their Christmas meal
When playing tug of war, with all the crackers, did reveal
Instead of toys and trinkets, inside brightly papered tubes
Found were things that smelt a bit, thus horror then ensued

Whether this be just a tale, the thought quite often lingers
Make a wish and hope that you don't find some severed fingers!

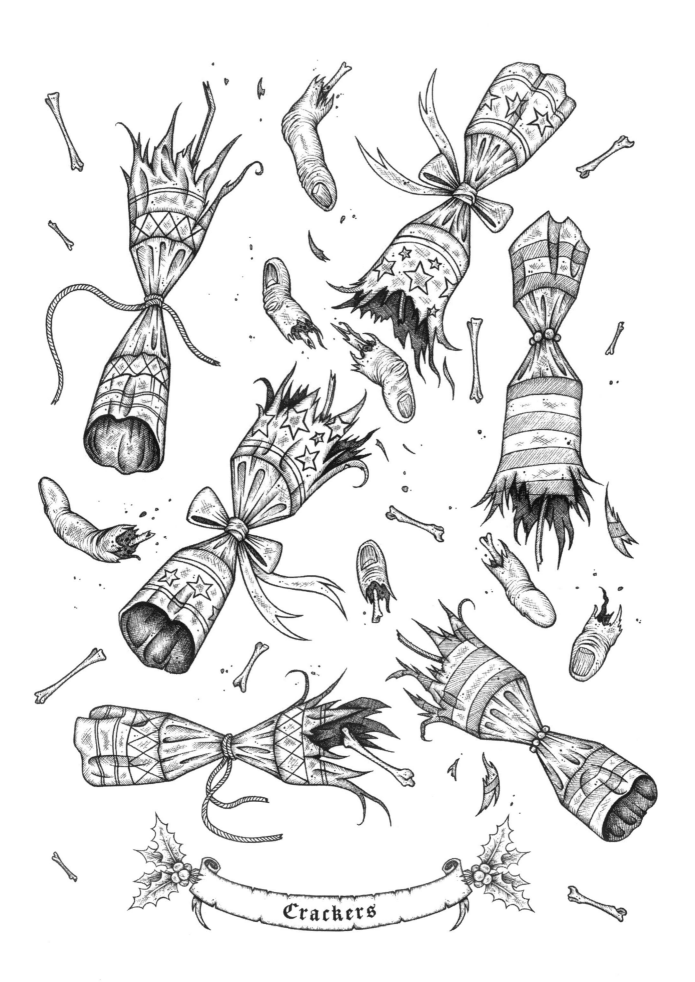

Crackers

The Abominable Snowman

The people of the Himalayas, Nepal, Tibet and Bhutan
Talk of a creature, a beast, a monster
The Abominable Snowman

He's said to be part ape, part man … somewhere in between
Though way up in the snowy mountains
He's seldom ever seen

Considered by some as legend
And nothing more than myth
Some say he's kin to Sasquatch and Bigfoot are his kith

Science thinks he's just a bear
One as yet undiscovered
But the mystery of the mountain man is very much beloved

A prehistoric bear maybe, or is he just a tale
Thought by some a trophy goal just like the Holy Grail

His foot prints are his calling card, he's certainly some size
And since the 1920's, his name's been on the rise

A "Cryptid" he's referred to, when laying down the facts
A hidden animal indeed, we've only seen his tracks

The Sherpa call him "Metoh-Kangmi"
"Man-Bear" - "Snowman"
A terrifying giant beast, who'll shorten your lifespan

We're told his fur is red or black not white as you might think
One thing that can be said for sure, this creature sure does stink

He's thought to dwell in forests, either side of the range
He doesn't live in snowy mountains, which you might think is strange
Instead he'll travel across the peaks to get to his food source
Or perhaps he's looking for his perfect mate of course
Until we find a body, or conclusive evidence
Most people sit, with a stiff upper a lip
Firmly on the fence

Some say he does not wander, through the mountain mists
They say the Snowman can't exist
Yeti does!

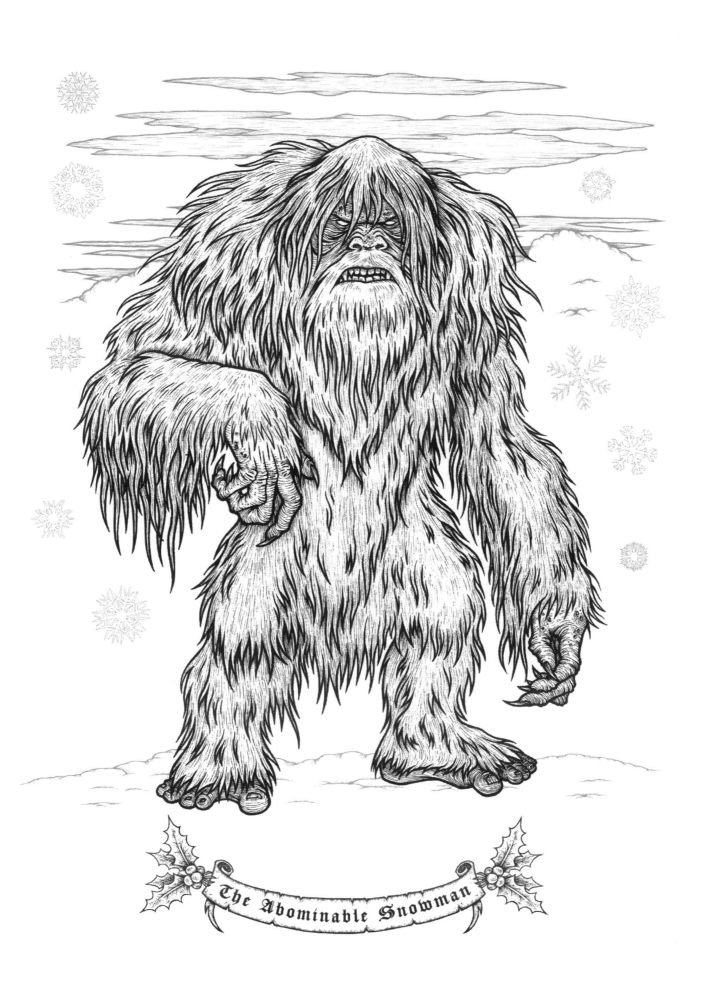

The Abominable Snowman

Shocking Fillers

Long ago as the legend goes
A father with three daughters it's told
Could not afford to have them be married
He was too poor and much worry he carried
For what would happen to them should he die
There was nothing to leave them, of riches he was dry

Santa, overhearing the village folk
Of this poor man and his daughters they spoke

Santa wanted to help, with concern he did sigh
To learn the poor man, had too much pride
To accept an offering, or charity he'd shy
His desperate situation … he would always hide

So instead Santa crept, to their window at night
Into their stockings, three golden coins did take flight
Some say golden balls were the things thrown swift
Three oranges today represent such a gift
Even pawnbrokers use these three golden balls
As part of their logo, on their signs and walls

Now if you're well behaved and you're good all year
Santa will also fill your stockings with gear
Some little toys, or little wrapped gifts
Deep into the stockings your hands they will sift

Under the tree he'll leave gifts that are bigger
Depending on how big your heart is the trigger
But if you're naughty, with a bad little soul
Inside your stockings, you'll find nothing but coal
A black little lump, covered in soot
To remind you of karma and what is afoot

For just like the coal, your soul will burn
Be good, for goodness sake it's not hard to learn
Krampus might snatch you, away off to Hell
There you will suffer and sizzle and smell

Upon the fireplace, the stockings are pinned
Sat high above flames that would lick at those sinned
Faces appear in the flames and the grill
Be good and with gifts your stockings will fill!

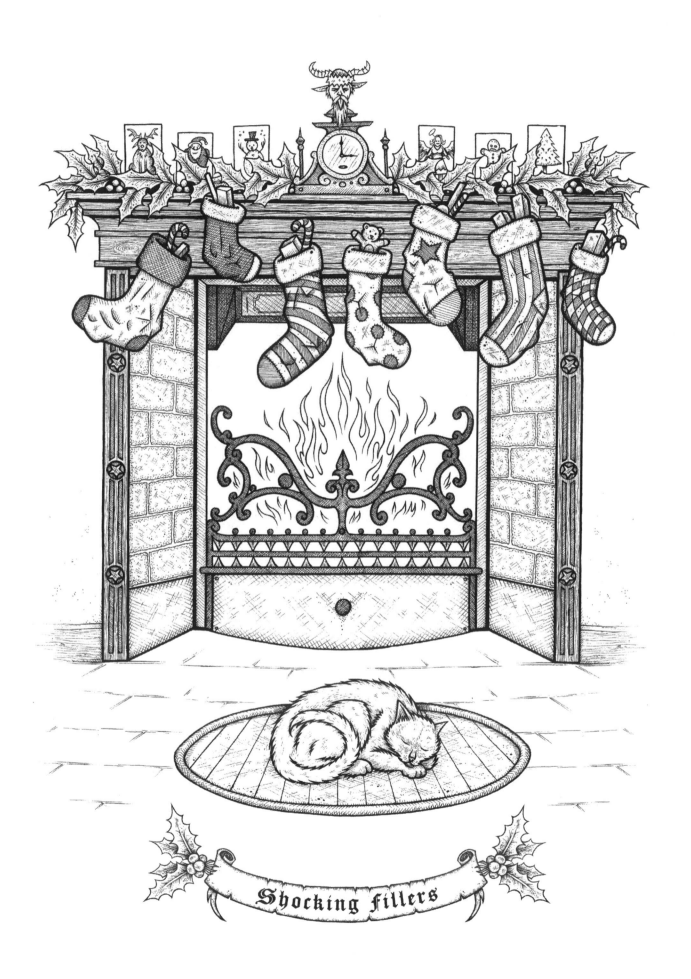

Shocking fillers

Past, Present, & Future

The ghosts of time, the spirits of ages
Past, present and future, through mythology rages
Through fiction and fantasy, legend and lore
As Dickens once wrote and as Poe, nevermore …
A reminder of death, messengers of such
Into the madness of memories clutched

Borrowing a talking raven did Edgar
From Dickens no less, with supernatural flavour
The fate of our future cannot be undone
Such as the things in the past, so think on
But forgiven by the spirit of things yet to come
If we act on the present before it is gone
A miserable life, bitter you might lead
Behaving to others with selfish greed
"The Spirit of Christmas Past" may turn up
To show you just why in foul moods you are stuck

Perhaps you've forgotten, or you've blocked it out
Painful memories have caused your own cruelty no doubt
This ghost of the past will dredge up thoughts tossed
Of lonely childhood, or perhaps lovers lost
Deny as you might and extinguish the light
This spirit simply wants you to see
Of the things that once were, do not blame him or her
It's just the first of these ghosts which are three

If not convinced, to change your ways
By the first of these spirits, staying stubborn …
Then the next of these ghosts representing the present
Will show you the cruelty you govern
Reminded you'll be of the things you have said
Perhaps wishing for others to quickly be dead
Perhaps suggesting a prison or a workhouse for others
Ignoring all those that poverty smothers
Not laying down guilt, but opening your eyes
At the stroke of midnight, this spirit flies …

Then faced with the last of these ghosts to lay blame
"The Ghost of Things Yet to Come" is its name
You'll be shown the cruel future, your name on a grave
Unless the unfortunate others you save
So spread good will, towards one and all
Or into a forgotten grave you might fall!

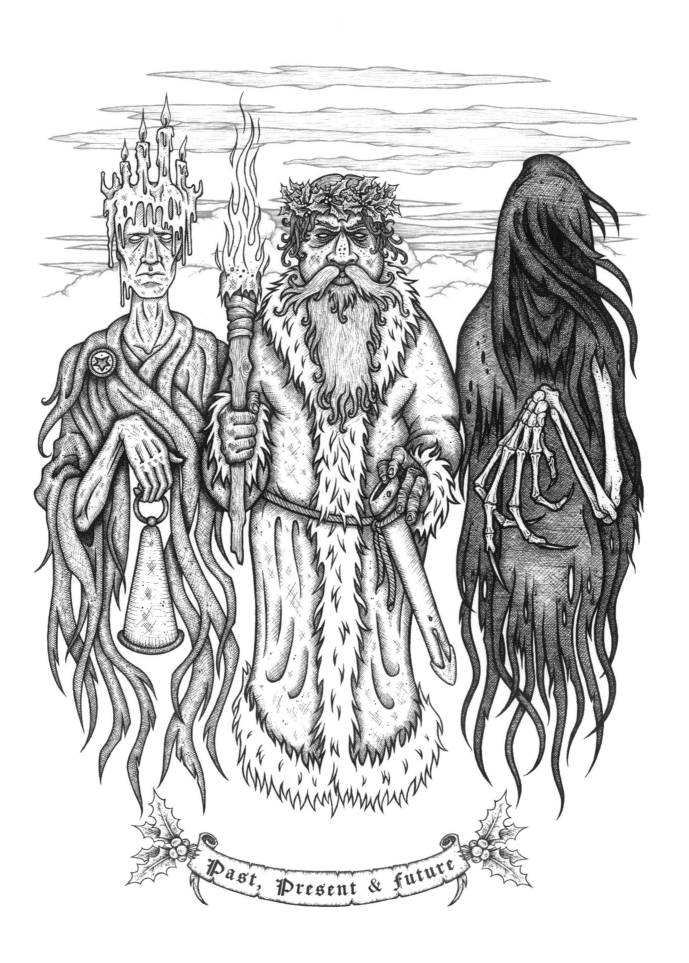

Past, Present & Future

The Feast

Whether it be chicken, goose or lamb
Maybe roast beef or perhaps some smoked ham
Perhaps you're cooking some venison or duck
Vegetarians don't care, they don't give a … shred of desire in the world for meat

Every single culture across the earth
Prepares a feast for their families, of great size and of worth
From London to New York, from Paris to Perth
People can't help, but increase the size of their girth

To fuel them through winter and keep them well fed
To gorge on huge heaps of meat and fresh bread
With piles of potatoes and lashings of mash
With stuffing and gravy, fake coins - chocolate cash!

Perhaps you've a turkey, the biggest you'd find
Now knowing there's enough meat for the whole family in mind
A nice bowl of roasties, some broccoli and sprouts
Some carrot and swede for seconds they'll shout!

Don't forget dessert, perhaps a good pud
Dripping in custard and cream it's so good!

Though one thing on this list, try not to forget
Before you start cooking you might need a vet …

For some of your choice foods you might drive
Well out of your way, to obtain the prime prize
Great distances you may go, to buy grass-feds who thrive
Just check before cooking, they might still be alive!

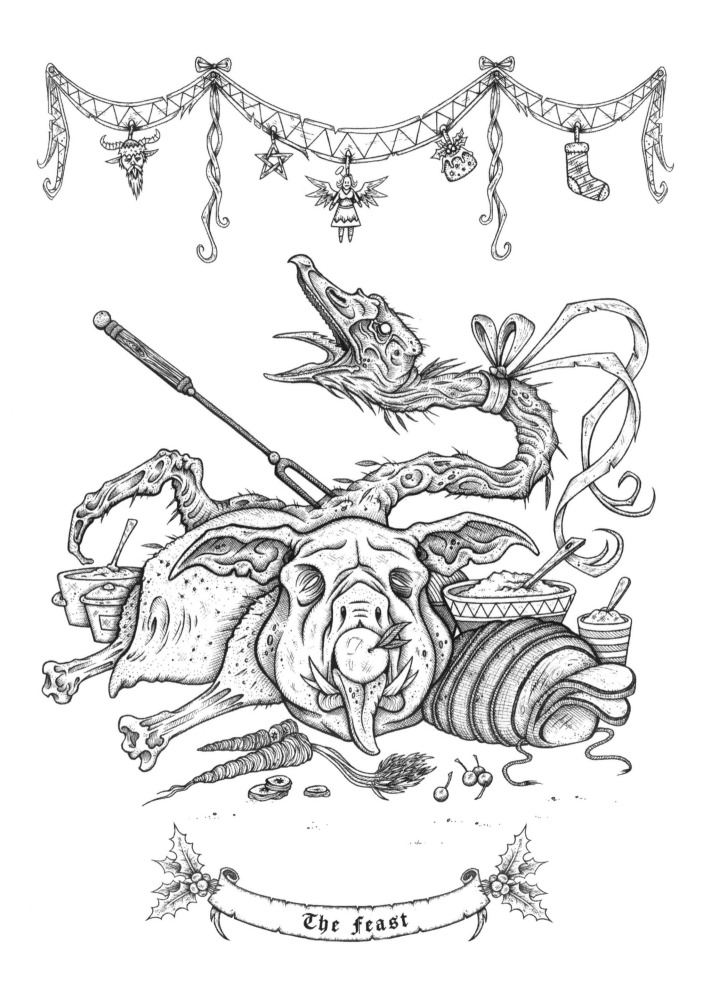

The Feast

Trolls

Though you'll find these dangerous beings, all year round it's told
The worst time to run into one, is when it's very cold
Now as the icy wind sets in, with sheets of sleet and snow
The last thing that you'll want to yell at Christmas time is TROLL!!!

Some are large, some very large, some are larger still
Others just the size of men and live among the hills
Most are thought to be quite slow, dim-witted do say some
Though dangerous, remain do they, regardless of how dumb

Known to some as man eaters, to others mountain men
But doomed regardless you would be, if dragged off to their den
A pile of skulls and bones you'd find, deep inside their cave
No matter what, they'll still eat you, even if you're well behaved

These monstrous giants, ugly ogres
hideous, horrible hordes
These hulking beasts are nature spirits, of the forests and the fjords
But don't let this confuse you, don't let your guard down, as a rule
The natural world, super or not, can of course be very cruel

Supernatural considered much, un-Christian they are known
They crumble in the sunlight rays, as they will turn to stone
Trolls in winter are the worst, as they hide in the fog
If overcast they're out in force and act like rabid dogs

Lightning from a thunderstorm, is something that they fear
The dinning of a church bell, a ring they hate to hear
The bells have driven many of these Trolls far far away
Though some smashed churches down, with boulders
So those are there, indeed to stay …

Be warned when in the wild in winter
On the mountains don't forget
Don't wander off into the fog
This is something you'll regret
They wander there, they dwell in wait
For unsuspecting prey
They can smell the blood, of a Christian man
From several miles away

Hard not to simply die of fright, however brave you are
To see for real, a living Troll, in Scandinavia

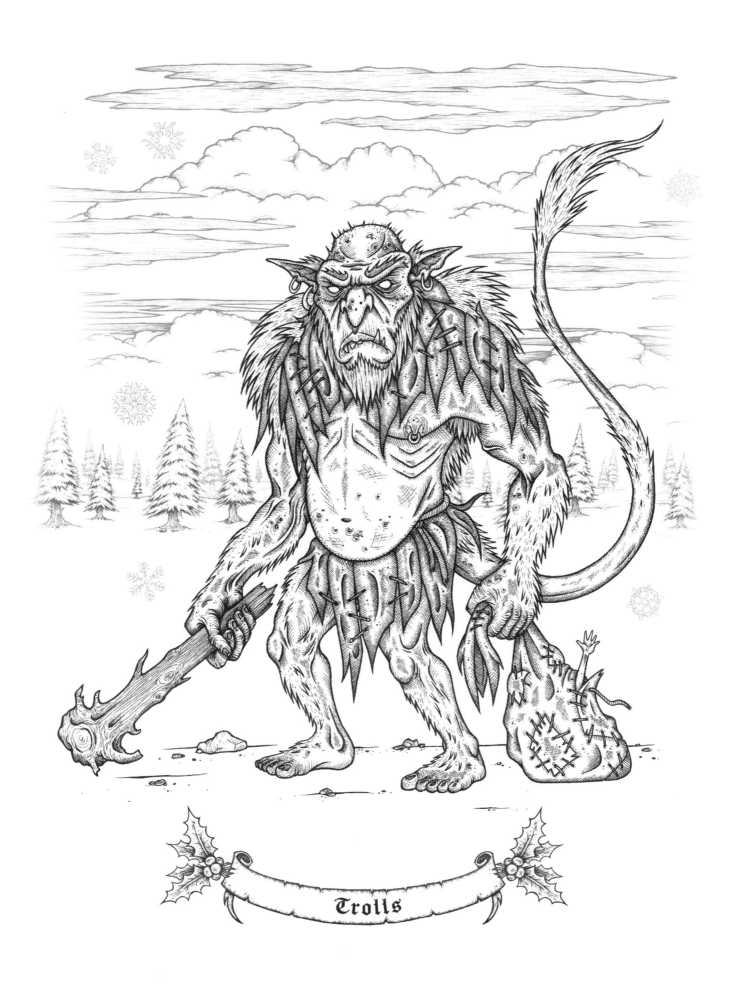

Trolls

Tomtenisse

The "Tomte" or "Nisse" or "Tomtenisse"
Are said to expect you to be their ass-kisser!

They're a mythical folk from Scandinavian lands
Who only have four digits upon their little hands
They're said to be short, less than a foot tall
Though from "Little Man Syndrome" they don't suffer at all

Legends say they're a shape-shifter and thus can change their size
From a few inches in height, they transform at will
Sometimes larger than a man they can rise
Some say they can vanish, become invisible, in a blink
You may only catch a glimpse, "what was that!?" you might think

In many respects they resemble a gnome
But not of the garden do these fae-folk roam
Instead they dwell, in burial mounds, tending to the forest as they perform their rounds

Some are adorned, with very long hats, others wear knitted, red or brown caps
Some are clean shaven, some have a beard, some have one eye, which looks really weird!
Their eyes glow at night, just like a cat, their pointed long ears sticking out of their hats
Mistaken as goblins these beings are not, they're actually quite helpful, when given a shot

Respect they expect and will hold you to such, though really in truth they don't ask too much
Try not to offend them, look after your farm, then nor you or your livestock will come to any harm
Their favourite animal, it is said, above all is the horse
When their manes are found braided, it's their doing of course

But should you annoy them and create a mess
They'll equally cause you torment and distress
They might be small but possess immense strength
With repercussions of vengeance they'll go to great lengths

So, leave them some porridge with butter on top
But don't try to trick them, else you'll get the chop
They might flick your ear or worse kill your cattle
This spirit, like a poltergeist, will give you a battle!

They'll upturn objects and break things you love
If you're lazy or spill things, they'll respond with a shove
With a poisonous bite they'll give you a nip!
From a bottle of courage you may want to sip
As should you upset them and be found on their mound
You may find yourself laying, six feet underground!

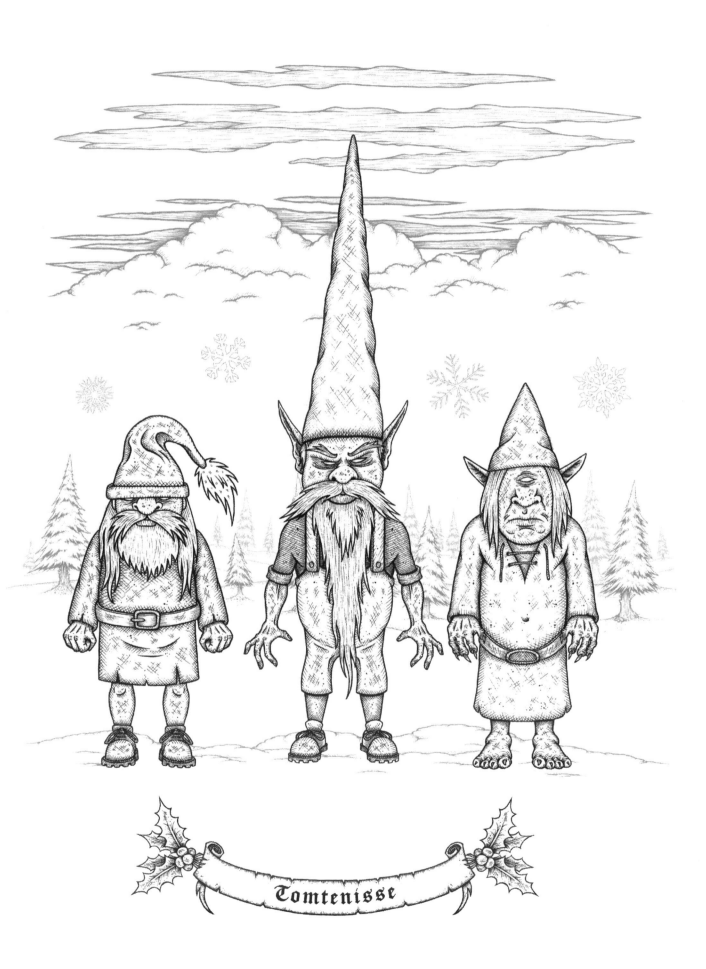

Tomtenisse

Grýla & The Yule Cat

Her name is thought to mean "threat" or "threatening"
Her role it's told, was behaviour reckoning
She'd seek out the children who were badly behaved
From her clutches it's said, you couldn't be saved
If you were naughty or acted poorly with greed
She'd snatch you away, on your flesh she would feed

A mountain giant, an "Ogre" or "Ogress"
Not unlike a horned devil, from Iceland no less
Like Krampus she's hoofed, with a long troll-like tail
Some say thirteen, though that tale is pale

In fact, some say, she has three heads
Each head, it's said, has one eye
Either way her appearance isn't pretty at best
A monster, no one can deny

She's huge and she's ugly, a great hairy beast
On the bodies of babies, her favourite feast
She'll sniff out the naughty, throughout the year
Then at Christmastime, cook a stew it was feared
The main ingredients, of course, disobedient young
Her insatiable appetite, this great worry was sung

Though if you were good, you'd have nothing to fear
Yet wanting to meet her, wasn't something you'd hear
She wasn't the type to grant wishes you see
Not like Santa at all, you couldn't sit on her knee
She'd gobble you up, without a care if you're good
You'd be a rare treat, as sweet as your blood

She lives in a cave with her third husband and sons
The thirteen "Yule Lads", thought as trolls were to some
Part of this family includes the "Yule Cat"
A great feline beast, a rather large one at that
Bigger than a lion, some say by far
Though really that isn't so strange or bizarre

This cat, this Icelandic predator of lore
Would hunt down certain folk due to clothes that they wore
For if you walked around, all day in old garbs
The Yule Cat would eat you, without a care for your carbs
Be sure to gift others, new clothes or a hat
And remember your own, don't be prey for the cat!

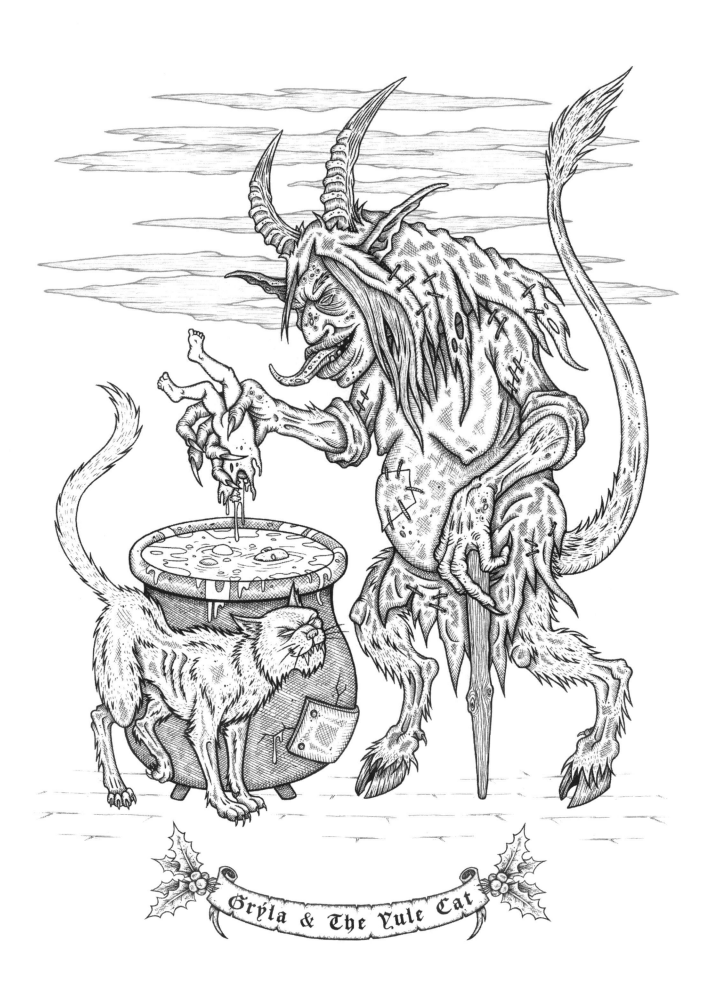

Grýla & The Yule Cat

The Messengers

In much of the western world, as far back as ancient Greece
The owl was seen as a symbol of wisdom, to say the very least
Though seen around the world, representing so much more
Some might say these birds are infamous, found throughout folklore

Among the Kikuyu of Kenya, they're the harbingers of death
These messengers when seen it's said, foretell your final breath
In Native American folklore, they are warnings, it is spoken
Of a supernatural sort it's thought, also by the same token

"the owls will get you" they would say, to children misbehaved
The hoot they'd hear at night was said, a calling from the grave
Told to remain indoors at night and not to cry too much
The threat of being carried off into the night was such

Believed to carry messages, from the other side
Their word within the wind was wildly said, from those who'd died
For witnessing an owl that speaks, with a human tongue
Was seen to be a sign your end of life would not be long

In the Popol Vu, a religious Mayan text
If visited by an owl it's said, to die you may be next
Mictlantecuhtli, the Aztec god, of the ancient dead
Took the form of an owl no less, carved in stone was read

The messenger would visit you, from the "Place of Fright"
In Mayan called "Xiblaba" a place of perpetual night
To this day in Mexico, a saying there still flies
"When the owl cries or sings, the Indian dies"

These nocturnal feathered faces, as omens of death are feared
Their starring eyes, their judging gaze, can silence any cheers
These birds of prey, these old wise ones, respected they must be
For everything you do that's wrong, they'll know, they'll sense, they'll see

If you're visited at night in winter, by an owl that stares at you
Be sure to kiss loved ones "good night"
As your life may soon be through

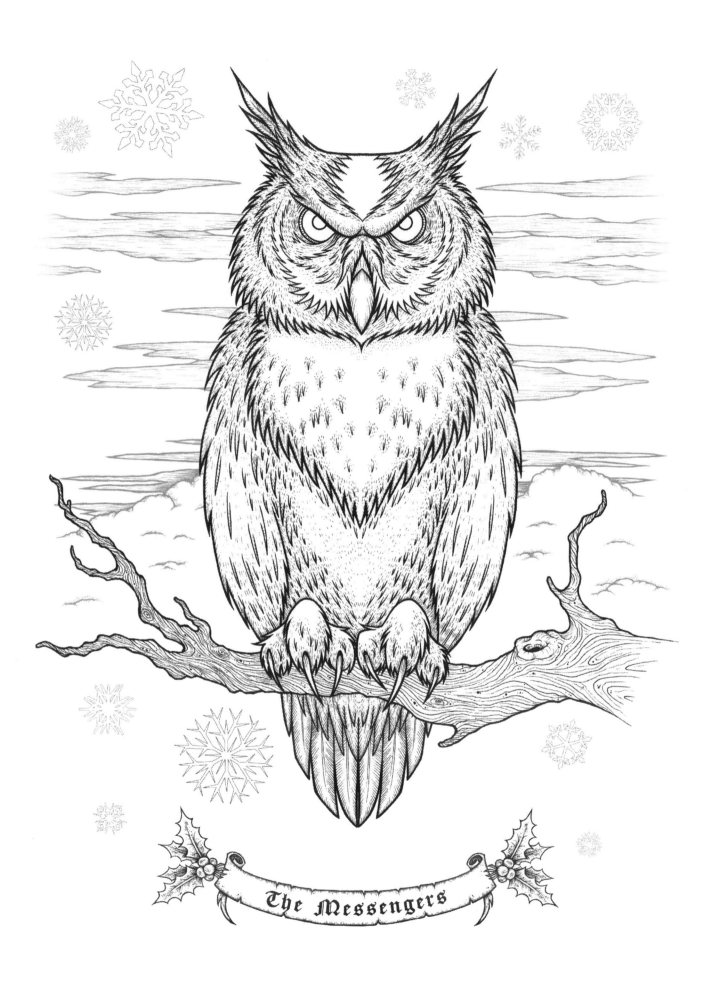

The Messengers

Snow Demons

With every winter's legend told
No matter the origin, or however old
The great elder ones who spread the fear
Whose warning bells, signal them near
Are all in need of a little help
Though not from angels or from elves

The snow demons, take many forms and go by many names
They accompany old Krampus and Perchta, so the legends say
They help gather up the ones who're naughty, and all who misbehave
They'll drag you off inside a sack or send you to your grave

Known to some as "Straggele", in legend "Forest Folk"
Half man, half beast - all demon
Their appearance is no joke

Some adorned with goat horns others look like deer
All bear horrid glaring eyes, their gaze alone strikes fear
Their teeth are spiked or broken, misshapen like a beast
If Krampus will permit it, on your very flesh they'll feast

Cloven hooves they walk upon and stride with ease through snow
Just how they came to be this way, is something we don't know
The myths speak of a curse of course, a spell cast by a fairy
These creatures were once human folk, though now forever hairy

A lumberjack may be transformed, into a bovine beast
A larger type, like the "Minotaur", robust to say the least
These are just "the muscle" and not so bright to match
Just used to haul the badly behaved, the latest batch of the yearly catch

Though fearful you must be, that they may cart you off
Some may simply beat your legs, or whip you in loincloth
They'll sit on you or chase you down
Half naked and all over town
Perhaps just to scare you and teach you a lesson
To be better behaved and to "Quit with your messin'"

Aside from the guide or the warnings that they teach
To be good and to be generous, with each strike they preach
Raising up their branches as they threaten to beat you
Be thankful above all, they're not going to eat you!

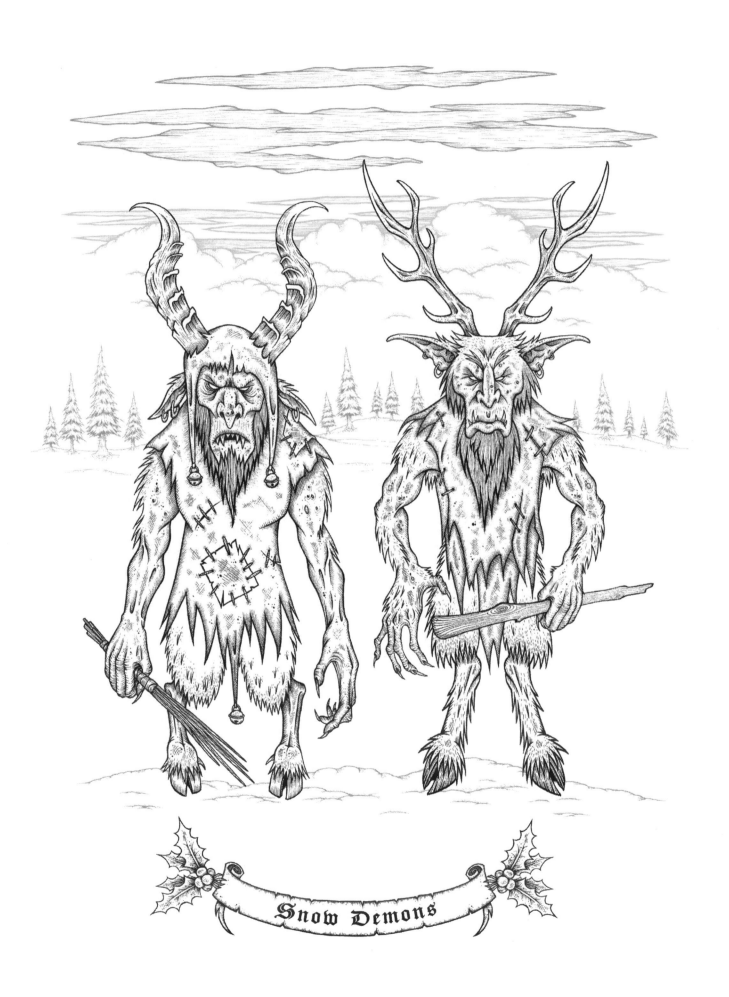

Snow Demons

Wreath Wraith

Made to last the harshest winter
This symbol of strength might give you a splinter
Perhaps a prick from a pine or holly
Don't hang these up with too much folly

In ancient times of Rome and Greece
In the age of the Hydra and the Golden Fleece
The wreath resembles a "diadem"
A crown once worn by ruling men

Since then also and to this day
The wreath is used at funerals and graves
The circle is its symbol here
To pay respect in remembrance each year

"The Hanging of the Greens", the everlasting life
A Christian act of decoration
Put up until twelfth night!

With the hanging of a wreathe
A sort of sign, with evergreen leaf
An immortal symbol of everlasting peace
Like a vampire's grin proudly showing its teeth

Some consider it be Pagan, to them a festive smite
Some choose not to hang the wreath, some see it as a blight

The forest spirits live within, each stem, each thorn and leaf
They hear your words, they sense your mood
regardless of belief

But some indeed use the wreathe
To call the woodland ghosts to roost
To bring the Green Man to their home
To give cold walls a colorful boost

Some use it to invoke old Puck
Some use it to attain good luck
Others say it just looks nice and really just don't give a … single thought …

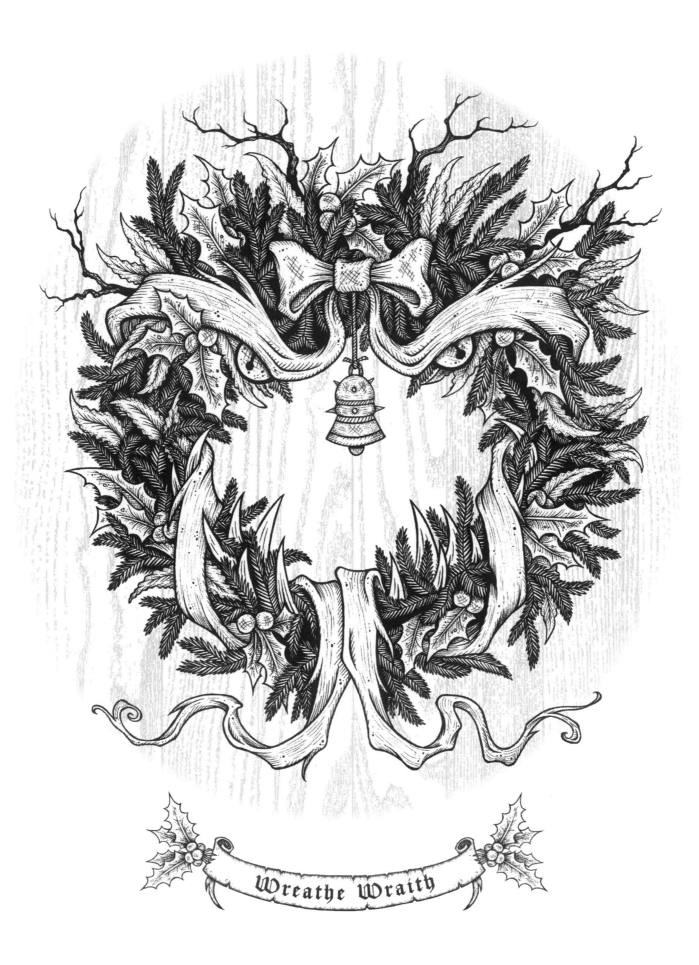

Wreathe Wraith

Father Time & Baby New Year

As winter rolls in and the year meets its end
We will all share our memories to our loved ones and friends
Those lost are remembered and given a toast
With a drink in hand we raise to our hosts
To be thankful for all, that is good and received
Life will go on, it must be believed

The cycle of life, from the womb to the tomb
May well be filled with doom and gloom
Whether lucky or not, to be bride or groom
Don't wish for the stars simply aim at the moon

The winter will fade and spring will return
Life's lessons continue, there's still so much to learn
So hold your head high and smile at sad times
The universe listens and answers your cries

Throw out the misery and bring in the cheer
Be positive not negative, look to the new year
As the older we get, with regrets full of sorrows
We must remember there's always plenty of tomorrows

As wrinkles appear and grey hairs turn white
As sure as the day will return from the night
Have faith there's a dawn, just out of sight
Don't dwell in the past, the future is bright

We're all going to die, no doubt that is certain
Destined to find what's behind the dark curtain
We'll weaken and pale and turn terribly frail
But our life and our stories, forever will sail

In our loved ones we leave, as we pass into death
Our legacy, our legends, they'll never forget
Just like "Old Father Time", replaced by "Baby New Year"
In death and life, we all must cheer

Life's too short not to think or care
But worry's like a rocking horse, back n' forth going nowhere!

So remember the fallen, those loved and lost
Live your life to the fullest, let sadness be tossed
Celebrate that you're here, raise the dead with a glass
Know they're on the other side, also having a blast!

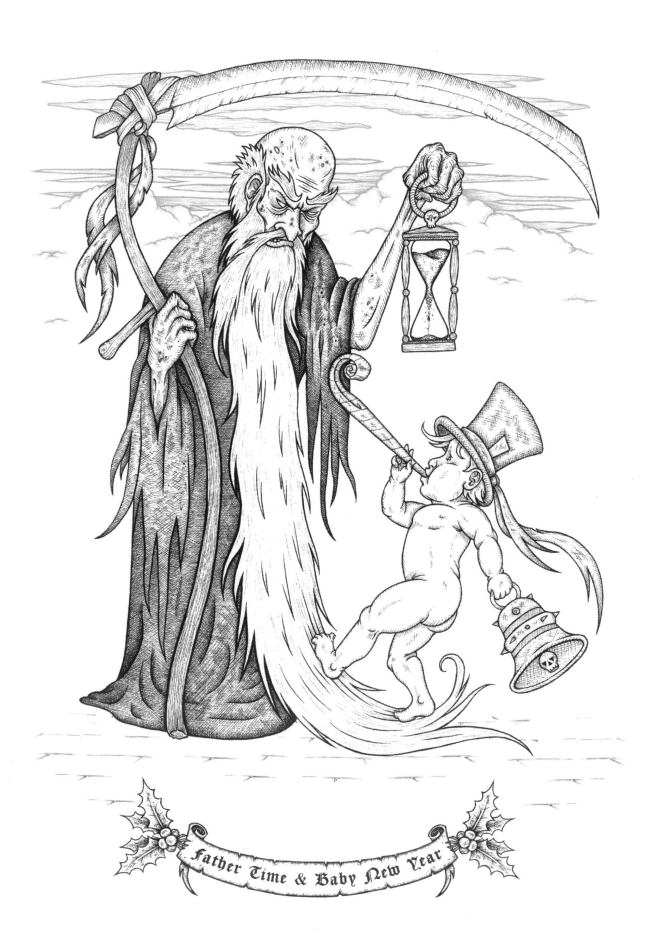

Father Time & Baby New Year

About the Artist

Mister Sam Shearon, also known as 'Mister-Sam,' is a British, Liverpool born dark-artist specializing in horror and science-fiction. Sam's work often includes elements inspired by vintage tales of monsters and madmen, dark futures, post-apocalyptic genres, and classic literature. His artwork can be found on a variety of books and comic covers, including illustrations for the Angel series, 30 Days of Night, The X-Files, KISS, Mars Attacks, Judge Dredd, Aleister Arcane, Richard Matheson: Master of Horror and the fully illustrated H.P. Lovecraft's The Call of Cthulhu, Oscar Wilde's The Picture of Dorian Gray, and Clive Barker's Hellraiser and the Books of Blood series. Sam has also created cover artworks concerning cryptozoology and the unexplained, with clients including David Weatherly, Lyle Blackburn, Small Town Monsters, Chase Kloetzke, Whitley Strieber, and the podcast Into The Fray for which he also co-hosts.

Various examples of Sam's art work can also be found in magazines such as Fortean Times and Paranormal magazine, Heavy Metal magazine, LA Weekly, and a number of British newspapers, most notably the Daily Telegraph. He has also illustrated album artwork and merchandise designs in the rock and metal music industry, with previous clients including Rammstein, Rob Zombie, Biohazard, Fear Factory, Jason Charles Miller, Powerman 5000, American Head Charge, HIM, and Iron Maiden.

Sam studied at the University of Leeds in the College of Art & Design, West Yorkshire, England and received a BA with honors in Visual Communication. Sam was also awarded a post graduate certification in teaching from Huddersfield University. Sam is known for his work in the field of cryptozoology, most notably for compiling artist impressions from eyewitness accounts.

www.mister-sam.com